Preaching with Relevance in the Twenty-First Century Church

Paul A. Hylton

WestBow
PRESS
A DIVISION OF THOMAS NELSON

Unless otherwise indicated, Scripture quotations used in this book are from The Holy Bible, New King James Version (NKJV), copyright © 1979, 1980, 1990, Thomas Nelson, Inc., Publisher.

WestBow Press books may be ordered through booksellers or by contacting:

WestBow Press
A Division of Thomas Nelson
1663 Liberty Drive
Bloomington, IN 47403
www.westbowpress.com
1-(866) 928-1240

ISBN: 978-1-4497-1955-5 (sc)
ISBN: 978-1-4497-1958-6 (hc)
ISBN: 978-1-4497-1957-9 (e)

Library of Congress Control Number: 2011932049

Printed in the United States of America

WestBow Press rev. date: 09/28/2011

Contents

PREFACE

The material in this book is derived from over thirty-five years of observation, study, and lecture on the subject of preaching. I have travelled to numerous nations preaching and teaching leaders about the importance of delivering the gospel in a compelling manner. This can only be done when the preacher is in tune to the Holy Spirit's leading, possesses a knowledge of the Holy Scriptures, and has a fundamental understanding of homiletics. I am indebted to my precious wife, Donna, for her help and inspiration during the process of writing the book. I must also thank Patricia Carroll, a dear friend and minister of the gospel for editing the material and encouraging me to complete the project. My heart's desire is to please the Lord and render the best service I can in my earthly stewardship. I hope that this book will challenge those called to preach the gospel in the twenty-first century to study, pray, and work hard in presenting the good news of Jesus Christ.

Paul A. Hylton

INTRODUCTION

I am from the last group of baby boomer that is 1959 to present. Having said that, I have lived a number of decades and I have learned a few things about this life filled with its rivers of joy, discovery, fascination, pain, and trials. Life is a combination of experiences that shape our perspective while revealing our purpose and destiny. I must confess that the first decade of my journey started out as young, innocent, and searching. I referred to my mindset at that time as being an agnostic, not really sure if there was a God, but open enough to be willing to accept Him if proven. Well, that is exactly what happened to me in the middle of my second decade. I had a life altering experience with the resurrected Christ that radically transformed my life and future.

Today, I am a messenger of hope traveling along the road of time spreading the good news of a loving Savior. As a Christian educator and missionary statesman, it has been my greatest ambition to equip others to be effective communicators of the gospel of Christ. Someone once remarked that an intelligent presentation of the gospel would win millions of people to the Lord. That brings me to the reason and purpose of this book. The only thing that is constant in this life is change and the longer we live the more changes we will experience on this side of eternity. Change produces adjustment and adjustment can be pleasant or unpleasant. It all depends on how we view the change that is taking place and our willingness to accept it.

What does all this have to do with preaching in the twenty-first century? Everything! The reason why this subject is so dear to my heart is because I have lived long enough, witnessing and experiencing change in the way the message of the gospel have been presented. And, I believe that the effectiveness of the message can be greatly improved if ministers of the scared scriptures were to prepare themselves to be outstanding communicators of the gospel message. I recently read this statement, *"Understanding the rules of homiletics do not in themselves produce effective preachers."* While I strongly agree with this statement, I must add that, with diligent work and passion, we would be amazed at just how effective we could be if we made a commitment to develop our skills for maximum impact.

CHAPTER ONE
Preaching with Relevance

"Preach the word of God. Be persistent, whether the time is favorable or not. Patiently correct, rebuke, and encourage your people with good teaching. For a time is coming when people will no longer listen to right teaching. They will follow their own desires and will look for teachers who will tell them whatever they want to hear. They will reject the truth and follow strange myths." 2 Timothy 4:2-4 (NLT)

We are living in a highly technological age that has certainly affected the way people perceive and think about life. The "pep" words of the day are "speed," "quick," and "right now." Anything that takes longer than a few seconds is considered slow. We need everything right now! And to wait implies annoyance and inconvenience. Our society is accustomed to fast food restaurants, drive-through pharmacies, cleaners, and marriage chapels. We now have drive-through churches for those in a hurry to get nowhere. These are a depiction of the times we are living in, and it has certainly influence the way the modern-day clergy does ministry from visiting the sick to preaching the gospel. The change of the mindset of the people in our society has greatly impacted both the activities and length of time spent ministering to people. The results are tragic; the preaching is limited to a few minutes saturated with comedy, illustrations, and a brief Bible commentary, if any. It is almost impossible to do justice to developing the text of the scripture and making the personal application under these conditions. The shallowness of the people should not stop preachers from preparing their message to achieve the maximum impact. People need good preaching, solid preaching, transformational preaching, relevant preaching, and messages that are saturated in the word of God delivered under the anointing of the Holy Spirit.

What is relevant preaching? It is preaching that is biblical, impactful, and current. Relevant preaching has at its core the centrality of the cross of Christ and the importance of the application of the text. The preacher must not compromise with the sacredness of the Holy Scriptures nor be a clown with the message of the gospel. Relevant preaching understands that "all we like sheep have gone away; we have turned every man to his own way" and only the power of the word can turn us back to our Creator. When Paul addressed young and timid Timothy, he made it very clear that he had a divine responsibility to preach the word of God whether it was popular, wanted, or accepted by his hearers.

The Apostle knew that they were living in perilous times because the spirit of the Stoic and Epicurean philosophers had infiltrated the church and had devalued the pure scriptural teaching from the word of God. In Acts 17:21 Luke tells us that these people took up residence in the market

place and debated all day with any and everyone that wanted to share their philosophy on life; "For all the Athenians and foreigners who were there spent their time in nothing else but either to tell or to hear some new thing." This same spirit is very prevalent in our society today and the warning to Timothy two thousand years ago is vitally important to the church in the twenty-first century. That is why relevant preaching is greatly needed. Most of our congregants are not interested in hearing the gospel message as it is communicated from the pulpit unless it has something new or thought-provoking to arrest their curiosity. Preaching with relevance will not undermine the integrity of the word of God to please its listeners with empty philosophical jargon.

Preaching with relevance requires expository preaching, but is not limited only to that approach in proclaiming the word of God. Expository preaching is one of the highest forms of preaching because it methodically engages in the exegesis of the text. I came across a clear definition by Haddon W. Robinson in his book entitled, Biblical Preaching; "Expository preaching is the communication of a biblical concept, derived from and transmitted through a historical, grammatical, literary study of a passage in its context, which the Holy Spirit first applies to the personality and experience of the preacher, then through the preacher, applies to the hearers." Why is this definition so important to relevant preaching? I would like to posit four components of expository preaching that deserve a closer look.

- "**Biblical concept**"—The core of the message starts with the Bible and ends with the Bible. The source of the message is the words of scripture. The Bible is not consulted as one would a dictionary when trying to define a word. The Bible is the primary tool used to proceed with the message.

- "**Literary study of the passage**"—The preacher must understand what the text means by way of studying it in its historical setting and then transition to the present day application. Most false doctrine has come about because the *text* was taken out of *context* and made to say what the preacher wanted it to say instead of what it was really saying.

- **"Application to the personality"**—Jesus said that the "husbandman must first be partakers of the fruit." Simply stated, the preacher should first make the application to his own life before he instructs others on how they should live.

- **"Application to the hearers"**—The goal of all messages should be the application of the scriptures to the lives of the people. How can the message be relevant if there is no personal application? The people must understand how the sermon relates to them. If there is no personal application, the sermon will be seen as gathering information only, but not as being relevant. It is more like sharing a book report in class on a particular subject that has interest for the reporter alone.

Preaching with relevance is solution-based preaching using the Bible as the remedy for the spiritual ills of mankind. In any given service regardless of size of the congregation, ethnic makeup, or age group, you will find people sitting there with a variety of issues and complaints. The complexity of their problems is beyond any preacher's ability to help them with just their words and experience. The people need a divine revelation from God through the scriptures to help them find comfort and solutions to the myriad of things they face. The Bible has the answer to most of the things people face. It covers subjects that most people never thought were in the Bible. Some of the subjects that the Bible addresses are: anxiety, backsliding, comfort, depression, relationship, money, forgiveness, enemies of the soul, faith, forgiveness, greed, hospitality, kindness, love, prayer, pride, selfishness, money, peace, priorities, procrastination, stress, success, temptation, time, wisdom, zeal, and the list is endless. Finding the answer is one thing, but the power of the scripture is experienced when a person makes the application by faith to his or her life. "But without faith it is impossible to please Him, for he who comes to God must believe that He is, and that He is a rewarder of those who diligently seek Him." (Hebrews 11:6) In order for the scriptures to work a person must have faith in them. The God who stands behind His word will never let them down. Even

when it may appear that way, God teaches the believer valuable lessons from the process.

Preaching with relevance is confrontational. This type of preaching deals with sin and the human heart. Preaching that dances around the subject of sin and is afraid to cry loud and spare not, will eventually develop a shallow congregation of worshippers who lack conviction. Sin is ugly and painful. It is sweet to the flesh, but bitter to the soul, and the end result is often painful to the sinner and saint alike, and sometimes those around them as well. To allow sin to flourish while the preacher ignores it is to commit the sin of omission. It is the responsibility of all preachers of the gospel to preach about what is wrong with the human heart. Jeremiah cried out, "The heart is deceitful above all things, and desperately wicked; who can know it?" (Jeremiah 17:9) The Bible not only heals us, but it cuts us, exposes our weaknesses, and confronts our hypocrisy. The Bible says, "For the word of God is living and powerful, sharper than any two-edged sword, piercing even to the division of soul and spirit, and of joints and marrow, and is a discerner of the thoughts and intents of the heart." (Hebrews 4: 12) The message must be balanced in its presentation and stimulating in its application. The entire counsel of the scriptures should be shared with the people. Preach to confront when necessary, but also preach forgiveness!

Preaching with relevance is done using the latest resources and materials that are available to the preacher. Our culture is addicted to technology and people today are communicating by way of Blackberries, iPhones, and other devices. They are stimulated by sight and speed. To reach this generation with the gospel, the preacher must learn how to use technology as a means of communicating the message. People like to see and hear things that are done through the medium that they can relate to and understand. The wise preacher will learn how to use computer software, videos clips, and other multimedia devices that are available to capture the attention of the listeners while sharing the message. These things are not meant to replace the traditional way of preaching, but rather enhance the preaching making it more appealing to a technology savvy audience. Some people will not like the changes while others will welcome them;

but the preacher must never be intimidated by the opinions of people nor be persuaded out of fear to stop growing in creative ways. The only thing that is constant is change, so preachers must make up their minds that they will make changes without compromising the message.

Who is in the Pew?

"Each generation of the church in each setting has the responsibility of communicating the gospel in understandable terms, considering the language and thought-forms of that setting" Francis Schaeffer

The preacher of the twenty-first century is faced with a very unique situation. Never before in the history of the Christian church has there existed such a wide variety of ideas and opinions among believers in the pew. And what is so daunting about this situation is the challenge it presents to the preacher in the pulpit. On any given Sunday the preacher will face people with various degrees of loyalties other than the Christian faith. I have identified six sub-groups that exist in most congregations to which the preacher in the twenty-first century will have to minister:

- The Facebook/Twitter Generation

- The Sports Enthusiast

- The Environmentally Conscious

- Those that are ADHD

- The Social Justice Group

- The Emergent Church

Let us briefly examined each of these groups of people and see what type of mental state they come into the church with and how the preacher can reach them with his message.

- **Preaching to the Facebook/Twitter Generation**—Both of these applications are a part of the popular social networking that uses viral phenomena to send messages and photos to friends and family within and without one's personal circle. According to Wikipedia, researchers say that there are over 400 million users worldwide with some 200 million being in America, and this number is swelling each day. Researchers estimate that some 350 thousand people join Facebook every day. For many young adults and teenagers, it is an addiction that is hard to break. According to iSMOblog Facebook: Fascinating Facts, the average Facebook user signs in about four times every day and 65 % of the user population spends about 21 minutes per day socializing in cyberspace. Facebook

is the top photo sharing website with about 4.1 billion photos on the site. The age range of the majority of users is from 16 to 46.

What makes this website so attractive to people? For starters, it is very easy to join, set up an account and to establish connections immediately. Because of the vast number of adherents around the world, people can find family members and friends that they may have lost contact with years ago. And people can keep up with the whereabouts and activities of their "stars" around the world. Who could have predicted in 2004 that then Harvard student, Mark Zuckerberg would have come up with such a culture-shaping vehicle that has revolutionized the way people communicate.

Preaching to this group is often challenging and frustrating because their attention during the service is split with one eye on the preacher while the other one is on their iPhone surfing their Facebook pages during service. One may combat this sort of disrespect in the assembly by asking people to turn off their cell phones when they enter the sanctuary, and by printing reminders in the bulletin, and by displaying notices on the overhead screen if one exists in the church. The primary reason why people engage in such activities during the sermon is because they are bored and find the sermon hard to follow and lacking in relevance to them. Knowing these things should challenge the preacher to make his sermons relevant and applicable to all groups within the congregation. It is not easy to compete with the fascination and excitement that one gets from viewing pictures of friends as they display their activities over their electronic devices, but the preacher must make every effort to communicate in a way that captures the attention of the young and the restless. The sermon should offer useful information that they can apply to their lives.

- **Preaching to the Sports Enthusiast**—What does the NFL, MLB, NBA, NHL, golf, soccer, rugby, track and field . . . have in common? Fans! Worshippers! People who live their lives through their teams. The love for sports and entertainment has grown enormously over the last few decades. Why do we love sports so much? I recently came across an article in the Bleacher Report Sports Newsletter by Rojo Grande, which articulates in a nutshell the reason why we love sports so much; "It is entertaining and provides a distraction from 'real life.' Additionally, we know that competitive athletics somehow stirs us at a gut level, either as participant or spectator." The action appeals to the side of us that seeks excitement and competition to round off our earthly existence. There are numerous kinds of sports and they vary from country to country, but the expectation is all the same. People want to identify with people they consider champions and winners and they live with the expectation that one day their team will win the top prize. What do people get out of watching sports? The experience is like a rollercoaster ride in which you experience highs and lows, ups and downs, and the entire process is exciting, stirring our emotions. Many people are passionate about their teams. Their commitment to sports teams picks them up when they are down and gives them something to look forward to and to cheer about. Some people live their fantasy through players on the field, while others see sports as a stress reliever from the chaos and boredom of life.

I must confess that there was a period in my life in which I was addicted to sports in general and the NFL in particular. I would watch the games, go online and read other opinions of the game after the post-game show, and buy the newspaper the next morning to read about what I had just seen for three hours. Then I had to listen to sports radio throughout the week to ascertain the latest predictions for the coming week's game. Thank God for deliverance!

Nothing has affected church attendance more than sports. Starting from a young age, when children should be in Sunday School learning about God and having their values developed for their adult life, they are instead on the soccer field or basketball court. I read that the Archbishop of the Catholic Church in New York having to call a meeting with the sports league of that area to request that they change the times of the games on Sunday because it was affecting the attendance at masses. Some churches cancel night services for the World Cup, the Super bowl, and other major championship games because they feel it is useless to compete with the events. It is difficult to understand the depth of such loyalty and passion to something other than God. However, millions of people in the pews on Sunday have divided loyalties between service and sporting events. If one was given a choice, the majority of the time the game would be preferred to the service except during times of personal crisis (sickness, death, etc.) or national tragedy (like 9/11).

How do you preach to the Sports Enthusiast sitting in the pews with one eye on the preacher and the other eye on his watch? He is listening with his ears while his mind is on the game that is in progress or is about to start. As the sermon lingers there is a level of restlessness seen on his face and the body language says, "it is time to bring this message to an end." Here are a few friendly suggestions:

- Learn the language of sports, i.e. know a few expressions and names of players, if the sermon permits, interject them at key points.

- Find ways to make the message so interesting and relevant that he will be so caught up in the message and he will forget the game.

- If possible, use hand gestures and eye contact, use voice pitch, punch (variation in loudness), and progress (changing the speed of delivery).

In their world of sports they are used to movement and speed and a preacher who stands in the pulpit without movement or facial expressions that show enthusiasm and passion will lose them as the message progresses.

- **Preaching to the Environmentally Conscious**—People who consider themselves environmentalists can be found in most congregations. An environmentalist is a person who advocates stewardship of the natural environment and sustainable management of its resources through changes in public policy or individual behavior. They strongly oppose policies that expose organic life to toxins, and waste that damage the environment. Let me state for the record that I am not saying or insinuating that there is something wrong with people who are very passionate about the environment. The Bible made it clear that mankind was given the responsibility to take care of the earth and to use its fruits as food (Genesis 1:28-30).

However, there are people who are very proactive in making sure that nature remains as is and it should not be disturbed for any reason. This is where conflict and controversy develop. As towns and cities expand to make room for more housing and industry, the need to use forest and open land becomes necessary and that normally sparks conflict. The environmentally conscious people see this as robbing the natural resources of both plant and animal life to expand into areas that are unnecessary. How does this affect the local church? As churches seek to expand and build, the need for asphalt parking space and tree removal becomes necessary. Environmentalists may not want to go along with the expansion or the use of certain materials that they feel will damage the environment. Most preachers

don't have a problem with people embracing strong views about the environment. I believe that it is a regional thing that affects churches normally located in rural areas or city churches that try to move into the suburbs.

Preaching to the "environmentalist" requires certain knowledge of the issues that are sensitive and offensive. Within this group are people who are advocates for animal rights and cruelty. They are against recreational hunting as a sport and the killing of animals that become overpopulated. The preacher must know or be aware of the many sub-groups within the congregation and learn the skill of navigating through each group's philosophy without creating ill feelings among members in the congregation through the message.

- **Preaching to the ADHD (Attention Deficit Hyperactivity Disorder) group**—ADHD is a biological, brain based condition that is characterized by poor attention and distractibility and/or hyperactive and impulsive behaviors. It is one of the most common mental disorders that develop in children. They have difficulties with concentration and mental focus. They are often characterized by "constant motion" perpetually on the go as if driven by a motor. This population is very visible everywhere. It includes the young and the old, preachers, doctors, teachers, technicians, athletes, entertainers, and everyone in between. I recently came across a website that gave me some helpful understanding about this condition. According to MyADHD.com, research:

> ADHD is not the result of laziness, poor motivation, low intelligence, disobedience, poor upbringing or selfishness—to name a few. Although having ADHD doesn't exclude you from having some of these difficulties, these problems do not cause chronic inattention, hyperactivity and impulsiveness—the core symptoms of ADHD. ADHD

is a medical disorder, and it can be caused by a number of factors that affect how the brain develops and functions. What factors could account for neurological differences in brain development and functioning that could contribute to ADHD? The main factors studied to date have been: fetal exposure to toxic substances (e.g., alcohol and tobacco) during pregnancy, exposure to lead, trauma to the brain from head injury or illness and differences that could be attributed to heredity.

Over the years in ministry, I have come across many people with this condition. At first my ignorant assumption was that they were being disrespectful with the constant movement during the service and at times during the message. However, through medical materials and lectures, I have come to realize that the condition I see is a direct link to this brain disorder and not the person trying to be disruptive. There is no lasting cure for this condition, but doctors say that the symptoms can be managed with medication, wise food selection, and behavioral therapy.

How do we preach to people with this condition? This can be a bit challenging if the preacher is easily aggravated by constant movement in the audience. I strongly believe that there are a few answers to the question.

- o If the preacher is aware of the person's condition, he should not let the movement distract him from preaching.

- o Don't see the impulsive movement as the person being disrespectful.

- o Try not to preach any longer than is necessary. Some preachers love to hear their voice because it appeals

to their ego. If the message is over then bring it to a close.

o Seek to get to the important points of the message while people are excited about the sermon. After 20 minutes even the serious saints begin to lose focus.

o Use object lessons to convey the main points of your sermon.

o Integrate multimedia and multisensory resources to enhance your main points and to diversify the delivery of your content.

o Pray for the Holy Spirit to control the thinking process and to arrest the attention of the people.

• **Preaching to the Social Justice group**—In the twenty-first century the word "social justice" has taken on a life of its own and has become a popular "buzz" word for the social activist seeking a cause to rally around. Social justice is concerned with equal rights and justice for everyone in society. It fights against any form of discrimination or policy that limits the potential of any human being. Some of the hot causes are: domestic violence, sexual abuse, mistreatment of gays, homelessness, better housing for the poor, universal healthcare, human trafficking, sex slavery, and a variety of other causes. These are all good and noble concerns for everyone to champion in society. These causes are not new, but over the past two decades small groups have been forming with a political agenda attached to their concerns. So it is more than championing a cause because of empathy towards the disenfranchised, political posturing is attached to the motive as well.

How do you preach to the social justice group in the twenty-first century? First of all you have to know the issues that are prevalent to society. Secondly, the preacher needs to know

what the Bible says about these issues (direct or indirect references). Thirdly, make sure that whatever position you take there is enough scriptural evidence to support it. Fourth, be proactive and vocal on issues that deeply affect people's lives. You may not be able to champion every cause, but God gives every church a special burden or vision for ministry in certain areas. Lastly, be faithful to stick to the cause and set goals and parameters so that progress can be measured.

- **Preaching to the Emergent Church**—This is the latest trend to come out of the body of Christ. The "Emerging" church is still emerging, so to have a clear definition might not do the subject justice at this time. Additionally, my writing is limited based on second-hand materials and personal observation. According to Julie Clawson, the author of Everyday Justice and a member of the Emergent Village Council, the Emerging church is "a decentralized Christian Movement exploring what it means to follow Jesus in our postmodern age."[1] She goes on to say that this new movement is "cross-denominational and cross-cultural . . . encompassing everything from evangelical conversations about being culturally relevant to mainline liturgical renewals . . .". Soong-Chan Rah, associate professor of church growth and evangelism at North Park Theological Seminary states that the emerging church reflects "ministry and theology rising out of the generation after the baby boomers." As a local pastor in the New England area, I have observed several things in the Christian community at large that help me to form my personal opinion on the subject.

 1. This new movement appeals to a younger generation of believers that is searching for the pure truth. The emphasis is more on spirituality instead of religious activity.

[1] Sojourners, May 2010 issue, Cover story

2. This movement often meets in places that are non-traditional in scope and void of religious symbols: no crosses, no stained glass windows, no religious art work, no pews, and no pulpits. Sometimes the meetings are held in a person's home or some large recreational space to accommodate the crowds.

3. The leaders are dressed in a very casual manner, no suits, ties, or liturgical collars.

4. The preaching is focused on *grace* not *sin*, on *forgiveness* not *repentance*, on *easy living* not *faith living*.

5. The worship is loud, stimulating, energetic, and non-traditional (no hymns), mainly worship songs that reflect the views of this generation. At times there is the lack of a deep commitment to the message of the cross and a walk that reflects the nature of Christ.

I read in a recent article the following statement concerning the emerging church, "preaching not centered in theology, but rather structure, organization, and transition from an institutional based church to a mission-driven church."[2] Although these statements have merit, I don't believe that it is true of all churches that classify themselves as part of the movement. Many of the churches have strong theological convictions and are preaching the gospel according to the scriptures.

[2] Dr. Robert Klenck, What's wrong with the 21st Century Church, Sojourners, May 2010

CHAPTER THREE

Preaching for a Response

"What the mind attends to, it considers. What it does not attend to, it dismisses. What the mind attends to continually, it believes. And what the mind believes, it eventually does." Earl Nightingale

At the heart of all preaching is the response from the listeners. This response is "transformation." The main objective of preaching is to see lives changed for the better. It is paramount that the preacher understands that all of humanity is hopelessly lost in sin and separated from the Creator. It is the proclamation of the gospel that will introduce them to their rightful place as children of God. The message of the gospel has the ability to touch every part of human emotions, which often causes a response, but a lot depends on the way the message is presented. This area is often overlooked by many preachers when they are studying and outlining their messages. This is the delivery of the message. I often tell our ministers in our local assembly that preaching is not just using words to convey their thoughts, it is engaging the audience and capturing their attention. If we fail to engage the people they will find other distractions to occupy their time while sitting in the pews. The effectiveness of our preaching depends on what we say and how we say it to the people. It is the preacher's responsibility to win the attention of the audience. And the minute they stand to preach they are judged and evaluated by the people as to whether or not they are going to listen to them. Not only do they need to start well, but they need to finish strong.

Words are important, and so are voice tone, body language, eye contact, and physical gestures. Psychologist Albert Mehrabian in his book *How to Read Body Language*, says the following, "Only seven percent of a speaker's message comes through his words; thirty-eight percent springs from his voice; fifty-five percent comes from his facial expressions." This says that people are watching the preacher as he preaches and more weight is placed on his non-verbal communication than on what he is actually saying from the pulpit. If the preacher wants to have impactful messages leading to transformation of lives, he must be conscious of how he is going to communicate the message from the standpoint of appealing to the heart and mind.

Preaching for a response means that the style and versatility are important. The Apostle Paul was known for his ability to connect with his audience while speaking. He was not locked into the, "one style fits all" mentality. He understood the importance of relating to his listeners

on their level. Let us look at a few of his sermons and then compare them to his audiences.

- Acts 17:1-4-**Audience**—liberal Jews and Greeks—**Message**—The resurrection of Christ—**Result**—Many Jews, devout Greeks, and leading women accepted Paul's message.

- Acts 17:10-12—**Audience**—Noble Jews and prominent Greek men and women—**Message**—The resurrection of Christ—**Result**—They received the word of God and searched the scriptures daily.

- Acts 17:22—**Audience**—Greek Philosophers—**Message**—To the "Unknown God" (very philosophical in his approach) **Result**-some believed and followed, others wanted to hear more about Christ.

- Acts 24:10-21—**Audience**—Governor Felix—**Message**—Paul appeals to the governor's knowledge of religion and refuted the false charges against him. He spoke about righteousness, self-control, and judgment—**Result**—Felix came under conviction.

- Acts 26:1-29—**Audience**—King Agrippa and wife Bernice, governor Festus—**Message**-The history of the Jews and God's promise to them, his Damascus road conversion experience—**Result**—King Agrippa said, "*You almost persuade me to become a Christian.*" Paul addressed these men with dignity and respect because of their position and then he appealed to their knowledge of customs and the Jewish religion. The word of God convicted them as they listened to Paul's message.

Paul was a very tactful communicator and therefore, used the best way to present the message of faith to each of these groups of people. His method won their attention and gave him the opportunity to share the gospel with them on a level that they could understand. Some were convicted, some

were converted, and some were cantankerous. But all heard and had a response to his message. When the gospel connects with anyone there will always be a response, whether negative or positive. The preacher is not responsible for the response from the listeners; that comes from the Word of God working in their hearts and the Holy Spirit bringing the conviction. However, the preacher must preach in such a way that people will be persuaded to make a decision one way or another for God. The preacher must use their imagination in seeking ways to be better communicators of the gospel. A note from the life of the apostle Paul will certainly encourage them to be effective and versatile in preaching the word.

> For though I am free from all men, I have made myself a servant to all, that I might win the more; and to the Jews I became as a Jew, that I might win the Jews; to those who are under the law, as under the law, that I might win those who are under the law; to those who are without law, as without law (not being without law toward God, but under law toward Christ), that I might win those who are without law; to the weak I became as weak, that I might win the weak. I have become all things to all men that I might by all means save some. (1 Corinthians 9:19-22)

Preaching for a response requires making the message clear and understandable so that the listener can digest what is heard and make an informed decision as to what to do next. If the message is confusing, complicated, or controversial, the listener will shut down and reject what is being shared. To be effective, the preacher must have a solid grasp on the subject matter and know how to package it in a way that will not create a wall between the listeners and the message. I have heard many preachers share from the scriptures and at the end of their discourse; I had no idea what they just said or what point they were making. The failure of members of the clergy to engage the people in the pew is due to a lack of knowledge of the subject they are dealing with as well as an inability to explain and clarify what the text says. When these two problems exist the result is often frustration for the listeners and a lack of interest in the message. Graduating with degrees in the field of theology is no indication

that a person is designed for the pulpit or called to preach. Like all crafts, skill and proficiency come from hard work, determination, and love for the work. When God calls a person to preach, he may not be ready for primetime but with time, patience, and hard work the abilities can be developed to do an exceptional job in the field.

Preaching for a response requires passion and enthusiasm. People can normally tell if a person likes what he is doing by the look on his face and the energy exerted in sharing the message. Preaching without passion is like trying to walk a marathon with a tack stuck in your toe, your walk is slow and painful and it is expressed on the face. Passion and excitement are contagious and invite people to join in and experience the feeling. The passionless preacher will put the people to sleep and turn first time visitors away from the church.

One of my favorite persons in the New Testament is Apollos from Alexandria. This young man had a heart and passion to preach the word of God; although he had a limited knowledge of his subject. But what little he did know he taught that accurately. Luke peeks into his ministry "Now a certain Jew named Apollos, born at Alexandria, an eloquent man and mighty in the scriptures, came to Ephesus. This man had been instructed in the way of the Lord; and being fervent in spirit, he spoke and taught accurately the things of the Lord, though he knew only the baptism of John . . . for He vigorously refuted the Jews publicly, showing from the scriptures that Jesus is the Christ." (Acts 18:24-25, 28). This young man had several things going for him: first of all, he had the right attitude for ministry (I will come back to that), secondly, he was gifted in communicating what he knew, he had great understanding of the scripture, but not all the knowledge. Thirdly, he was fervent in spirit. The word "*fervent*" means "*glowingly hot,*" this is passion. Apollos had a lot of passion for the ministry and it showed as he preached the word. Fourth, he was bold in that he was not afraid to confront the Jews publicly. Another thing that impressed me was that he was open for correction. When Aquila and Priscilla took him aside and explained to him the whole gospel, he did not get offended and bent out of shape. He received what they had to say and kept preaching. "A wise man will hear and increase learning, and a

man of understanding will attain wise counsel . . ." (Proverbs 1:5). Passion, the right attitude, boldness, and eloquence are the qualities that make a good leader. If we want people to respond to our messages, it is imperative that we deliver it with passion and enthusiasm and watch it spread in the form of joy and excitement.

CHAPTER FOUR

Preaching in the Power of the Spirit

"And when they had prayed, the place where they were assembled together was shaken; and they were filled with the Holy Spirit, and they spoke the word of God with boldness."
Acts 4:31

J ohn Stott, wrote:

> Preaching is indispensable to Christianity. Without preaching a necessary part of its authenticity has been lost. For Christianity is, in its very essence, a religion of the word of God. No attempt to understand Christianity can succeed which overlooks or denies the truth that the living God has taken the initiative to reveal Himself to fallen humanity; or that His self—revelation has been given by the most straightforward means of communication known to us, namely by word and words; or that he calls upon those who have heard His Word to speak it to others.[3]

The method by which the Almighty has designed to transmit the Good News is through preaching by vessels that He has commissioned. Paul said to the Corinthian church, "woe is me if I preach not the gospel." (1 Corinthians 9:16). He acknowledged that he had an inescapable responsibility to proclaim the gospel. Now that I have established the importance of preaching, let me introduce the primary thought here: every preacher needs the help and assistance from the Holy Spirit. Some preachers are gifted communicators, eloquent like Apollos, seasoned like Barnabas, energetic like Paul; but after all has been said and done the preacher still needs the anointing of the Holy Spirit in order to be effective and to see lasting fruit. The ministry of the Holy Spirit is vitally important for several reasons.

The preacher needs empowerment—It is vitally important to note that anyone involved in ministry needs the anointing of the Holy Spirit in order to be effective and to see fruit from the ministry. I cannot overemphasize the importance of the preacher depending on the Holy Spirit's power to give him unction in his preaching, creativity in his outline, and passion in his delivery. The Apostle Paul makes it very plain that all preachers need power in their preaching when he said, "And my speech and my preaching

[3] John Stott, Biblical Preaching Today, Grand Rapids, MI, Wm B. Eerdmans Publishing Co. 1961, p 15

were not with persuasive words of human wisdom, but in demonstration of the Spirit and of power, that your faith should not be in the wisdom of men but in the power of God." (1 Corinthians 2:4, 5)

Philosophical reasoning, eloquent speech, and self-confidence in preaching are not enough to transform the life of the unregenerate. It is the Holy Spirit working through the Word of God that causes there to be change in the heart of man. Paul recognized his human limitations and stated his dependence on the Holy Spirit's power in his preaching. John Baillie captures the essence of the preacher's need for help when he wrote this prayer:

> O Holy Spirit of God, abide with us; inspire all our thoughts; pervade our imaginations; suggest all our decisions; order all our doings. Be with us in our silence and in our speech, in our haste and in our leisure, in company and in solitude, in the freshness of the morning and in the weariness of the evening; and give us grace at all times humbly to rejoice in Thy mysterious companionship.

The preacher needs revelation—This is not some mysterious religious jargon that is uttered during a message. The word "revelation" means the disclosure of hidden truth. This revelation comes from the Holy Spirit opening the preacher's eyes to see and understand passages that may have been hidden or difficult to grasp. Jesus said that the *paraclete* (Greek) or Helper means called to one's side to help or give aid. In the 14th chapter of the book of John, the Bible refers to the work of the Holy Spirit in the life of the believer that it would be given to the disciples in Jesus' absence. "But the Helper, the Holy Spirit, whom the Father will send in my name, He will teach you all things, and bring to your remembrance all things that I said to you."(John 14:26). "However, when He the Spirit of truth, has come, He will guide you into all truth; for He will not speak of His own authority, but whatever He hears He will speak; and he will tell you things to come."(John 16:13). The Holy Spirit becomes the preacher's instructor and director during the course of his message. He comes to inform, inspire,

and influence what is being said and how it is being said. The two keys to having Him working in the life of the preacher are obedience and faith. The preacher must listen, follow, and believe that he is operating under the influence of the Holy Spirit.

The preacher needs boldness—One evidence of the Holy Spirit's presence in the life of the preacher is boldness. In Acts chapter 4 the Bible says, " . . . and they were all filled with the Holy Spirit, and they spoke the word of God with *boldness*." (Acts 4:31). The disciples preached the gospel fearlessly and courageously when the Holy Spirit's power came upon them. It is often very intimidating to preach truth today because the listening audience has become very cynical and judgmental of any messages that challenge them to change and to break with old sinful habits. Most people would rather hear messages that are less confrontational and straightforward. They want messages that dance around the real issues and cater to the whims of man's foolish heart. The preacher needs the spirit of Jeremiah, the disposition of John the Baptist when preaching, coupled with compassion and maturity to give balance to his ministry.

The purpose of the Holy Spirit is not only to empower, inspire, and influence, but also to give supernatural boldness to face a hostile world that is bent on destroying anything that is godly or has morals. Preaching in the twenty-first century requires boldness to stand against all the critics and skeptics.

The preacher needs convictions—Strong beliefs or truths that a person holds, by which he orders his life and makes decision based on these beliefs. He is fully convinced of these beliefs and is willing to take a stand for them regardless of the consequences. These convictions must be rooted in the word of God. Every preacher must have strong convictions about the things that he believes and preaches and at the core of these convictions should be the Word of God. Commitment to these beliefs keeps the preacher focused and faithful to his calling. It has been said if you don't stand for something, you will fall for anything.

Preachers without deep and true convictions are often likely to change their opinion and beliefs when they are no longer popular. We should

take a page out of the life of Daniel, who was brought into an ungodly environment as a captive from Israel. Both he and his friends managed to live a pure life void of the compromises that would go against their convictions. Without strong godly convictions the messages will be shallow, lacking in substance and the listeners will leave the church feeling empty and frustrated.

Preaching with relevance requires the assistance of the Holy Spirit in order for the preacher to have the impact that is needed to transform a spiritually dead world. There is no substitute for the Holy Spirit's power when it comes to preaching. A.C Dixon says, "When we rely on organization, we get what organization can do. When we rely on education we get what education can do. When we rely on eloquence, we get what eloquence can do. But when we rely on the Holy Spirit, we get what God can do."

CHAPTER FIVE

Preaching from a Manuscript

"Sermons are designed to touch the innermost being of a man, to arouse his conscience to a sense of guilt, and to motivate him to repent when there is a need for repentance." Dr. Nehemiah Martin Palmer

The songwriter says, "I don't know where I am going, but I am on my way." There is nothing wrong with extemporaneous preaching as long as the preacher is an astute student of the scriptures, possesses a photographic memory, and has strong mental discipline. If he is lacking in any of the above then the use of a manuscript or written outline is highly recommended. Some preachers frown on using an outline citing that it is unspiritual to do so. Nothing could be further from the truth. Preachers who refuse to develop an outline are either too lazy or too ignorant to do the work and the evidence is normally seen in a message that is shallow, repetitious, and lacking in content and structure. This is not to say that a person cannot preach without an outline, but it is normally better to have some form of an outline either on file cards, written in the margin of the Bible or on sticky paper than not to have anything at all.

The value of manuscripts is that they keep the preacher from straying from the subject. It also serves as a reminder as to the points of interest that they would like to present to the audience. Having an outline allows the preacher to work systematically through the text, and makes it easier for the audience to follow. The opposite can be said for those who do not embrace or see the need to use an outline. Preachers will sometimes jump from thought to thought without any connection to the main idea and leave the people to sort out what is relevant to the passage of scripture that was introduced in the beginning of the message.

Another reason why some preachers shy away from sermon outlines is that preparing the sermon takes time, energy, and patience, and for some the discipline is not there and they often give up without much effort, reverting back to their old ways. Great preachers use some form of outline because they understand the importance of the sermon and the need for it to have maximum impact on the hearers. They try to keep focus at all times during their message. Dr. Nehemiah Palmer, in his book *The Preacher's Dynamite*, comments "Sermons are designed to touch the innermost being of man, to arouse his conscience to a sense of guilt, and to motivate him to repent when there is a need for repentance . . . it must not be too rigidly tailored with high sounding sophisticated theological jargon. The sermon ought to be electrified with the power of the Holy Spirit behind the preacher."

Good sermons that are well put together and well executed will always leave an indelible mark in the minds of the people. The goal of the preacher is to please God and minister life to a people dead in their sins, struggling in their spiritual development, and sinking under the cloud of discouragement. When the preacher considers the many needs of the people he will seek to make it a priority to make his message applicable for them. It is the Holy Spirit working through the message that makes the application to the needs of the people. All the preacher has to do is work hard in putting together a clear, sound, biblical message that points the people to God. Having the message written in an outline form is one way that the preacher can work through it without losing his place or thought. This will help to maximize the impact in the minds and hearts of the people. They get more from the message; they can retain and recall the important points of emphasis, and when the preaching is over the information will stay with them. I encourage everyone called to the ministry to develop the discipline of using an outline; it will greatly enhance their delivery!

Developing the Manuscript

When it comes to developing the sermon structure the preacher must have a working understanding of "homiletics." The word homiletics comes from the Greek word, homilia, which means a conversation, talk, or set discourse. Simply put, it is the art and science of preparing and delivering sermons. And the purpose of the sermon is to address a specific need or problem from God's perspective. Therefore, all sermons must be founded on the Bible as its source. The preacher is God's representative to the people, and the Bible is God's divine revelation made available to mankind. The Bible is our guide, principle, rule, constitution, and manuscript for victorious living. And as the preacher develops the sermon it must be used as his primary source. All sermons should have five major parts to give the outline full expression: title, text, introduction, body, and conclusion.

If the sermon is missing any part, it will not be complete and perhaps not have the impact that it could have. Please, don't misunderstand what I am saying. We all know that God is able and does use our messages in a

profound way even if they do not comply with homiletical rules, but from a procedural position, the sermon is lacking.

The Title

The title of the sermon is sometimes referred to as the subject, topic, or theme. Messages should have a title for identification purposes. However, this is not the sole or most important reason for the title. Having a theme or topic gives the audience a focal point. The title is designed to keep the preacher focused on the subject that he is developing. Everything that follows should have some relationship to the title. What is the preacher talking about? The answer is in the title, i.e. "Salvation, the need of Man," "The Just shall live by Faith," "Jesus the intruder," these are examples of titles that allow the audience to understand what the message is all about. I am only giving a brief paragraph on each of these areas. There is much more information that can be said about the title.

The Text

The first step in starting a sermon is the selection of the text, that passage of scripture that the preacher will be developing throughout the sermon. Dr. William Evans, Bible teacher, author and lecturer has said that the text is formed from the selected passage which the preacher develops in a systematic, orderly, fashion resulting in a complete and colorful message. The text can be a series of passages that relate to each other although taken from different places in the Bible. When selecting a text, it is best not to use one that is too long because people can get lost in the multitude of words, and miss the essence of your sermon. The text should be read in its entirety, if not too long. The preacher may get right to the key verses and explain the rest of the passage as he begins the message. The text is what gives the message biblical validity and supports the subject. It should be read clearly and loudly enough for all to hear and understand before proceeding with the preaching. The text should not be confusing, perplexing, or vague, but rather easy to be understood.

The Introduction

The opening statements of the introduction set the stage for the body of the sermon. It should not be too long and should move smoothly into the body of the message. The introduction is designed to capture the attention of the audience. The preacher can use a short story, joke, or illustration to break the ice and set the stage for the rest of the message. It is said of the introduction that you either hook 'em or lose 'em during the first five minutes of the sermon. There is no substitute for a good introduction that raises the audience's level of expectancy and sparks an interest. Great preachers understand the value of a good introduction and have learned how to master it. The audience knows in the first few minutes if they are interested in what the preacher has to say by the way he starts his sermon. Body language, facial expression, voice pitch, and word usage in the opening statement determine whether or not the people will listen. The introduction sets the stage for everything else. People can be very discriminating and closed-minded to preachers that they don't like. This is of no fault of the preacher, it is just human nature.

The Body

The body of the message is the main part of the sermon where the preacher develops the message and reveals his full aim and goal for the text and title. He builds his message in a logical and systematic way by combining appropriate scriptures, quotes, illustrations, exegetical passage interpretation and brief stories. Most manuscripts will have divisions and sub-divisions in the body which help to keep the preacher from wandering off into unrelated areas. Only the truly disciplined ones will survive the tedious work and research needed to make the message a wonderful work of art for the kingdom. Many start out well but fall by the wayside due to laziness, tiredness, lack of creativity, and motivation. Preachers must be readers! It is very important for preachers to realize that this vocation requires a constant intake of knowledge. Reading must be a part of the daily diet and reading the right material is also important. The scriptures should be the priority choice of reading material, then both religious and secular materials should be used as source material. The more knowledgeable the

preacher is on a variety of subjects the more he has at his disposal when he begins to put his message together. Solomon said, " . . . because the preacher was wise, he still taught the people knowledge; yes, he pondered and sought out and set in order many proverbs. The Preacher sought to find acceptable words; and what were written was upright—words of truth." (Ecclesiastes 12:9, 10).

The Conclusion

The conclusion of a sermon must be similar to the introduction, brief and to the point. This is the area where the preacher summarizes what has been said and emphasizes the personal application of the message. At this point, he should also press for a decision or specific action. The audience should see how what has been said relates to them. I might also add that the personal application should be done throughout the entire discourse. It is important for the people to understand how the message relates to the issues and challenges that they face in life. A message is never complete until the personal application is made. Dr. Nehemiah Martin Palmer stated " . . . the preacher's aim is to make men more godly, more holy, more patient, more upright in their hearts, more honest in their daily business transactions, more patient and forgiving with their loved ones at home, more merciful and compassionate, more willing to give to the cause of Christ, and more determined to follow the example of Christ." The focus of the message should be transformational and inspirational. Preachers preach to see people changed into the image of Christ. The conclusion of the message should bring people to make a decision one way or another. Then the preacher must trust the work of the Holy Spirit to press home the points that have been discussed by bringing conviction upon the hearers. Only the Spirit of the living God can transform a life, change a heart, and inspire a soul to desire a relationship with God. "Let us hear the conclusion of the whole matter: Fear God and keep His commandments . . ." (Eccl. 12:13).

CHAPTER SIX
Profile of the Preacher

"Character is always lost when a high ideal is sacrificed on the altar of conformity and popularity." Anonymous

Average preachers come a dime a dozen, but a good preacher is a rare species worth his weight in gold. Why do so many settle for mediocrity, shallow living, and a life filled with compromise? Because it is easy to do just enough to meet the demands of the people while neglecting the true responsibility of the calling as a messenger of the kingdom of God. The cry of the twenty-first century church is to find real, authentic, servants of the Most High. These days, with all the distractions of our society, anyone active in the ministry must be focused, committed, disciplined, and faithful. Ministry begins with a call from God. Without this special call from heaven, no one should venture into the ministry to be a preacher. A careful study of the scriptures points out the importance of this call.

The call of God is a personal invitation from God to be a part of His leadership team in the kingdom. There are at least four aspects to the call of God. Throughout the New Testament, we read that Jesus called His disciples and that the Apostle Paul mentioned the call in several of his letters. In Mark's record of Jesus appointing the twelve disciples " . . . and they came to Him then He appointed twelve, that they might be with Him and that He might send them out to preach." (Mark 4:13-14). This event is also written in Mark 10:2-4 and Luke 6:14-16. The Apostle Paul mentions the call of God on his life "Paul, called to be an apostle of Jesus Christ through the will of God."(I Corinthians 1:1). Similarly, he wrote to the church at Rome "Paul, a bondservant of Jesus Christ, called to be an Apostle, separated to the Gospel of God . . ." (Romans 1:1). In the Old Testament, we see the call of God in the life of Jeremiah "Before I formed you in the womb, I knew you. Before you were born I sanctified you; I ordained you a prophet to the nations." (Jeremiah 1:5). In Isaiah we see the call on the prophet, "Then I heard the voice of the Lord saying: Whom shall I send, and who will go for us? Then I said, here am I send me. And He said, 'Go, and tell this people:'" (Isaiah 6:8). The list of people that God has called is very lengthy and as we study their lives, we discover four things about the call.

- **The Call is Unexpected**

 Gideon was threshing wheat in the winepress when the Lord appeared to him and called him. Amos was a farmer attending

to his farm when the call of God came to him. The Apostle Paul was in a house getting over his traumatic divine encounter when Ananias gave him God's call. Moses was on the back side of the mountain tending sheep when the angel of the Lord appeared to him. To all these men, the call was unexpected.

- **The Call is Personal**

God calls us as individuals, not as groups of people. God makes Himself known to us in a personal way. When Paul had his experience with God, he saw the vision, he heard the voice, and he understood what was said (Acts 9), but none of his traveling companions heard the voice or saw the vision.

- **The Call is Undeniable**

There is no need for someone to convince you that you have received a call from God. It is undeniable and you are absolutely convinced that you have been called by God.

- **The Call is Transformational**

When Jesus called the disciples their lives would never be the same. He told them to follow Him and He would make them fishers of men. God changes a person's life in such a way that is totally transformational. He engenders a new outlook, a new goal, a new vision, a new purpose, and He puts the disciple on a track to discover his or her destiny.

It is amazing how many people enter the ministry to be preachers of the Gospel without a call from God. The evidence of the lack of a call normally surfaces when they encounter difficulties and challenges. Then, because the call is not something that consumes their entire being, they are ready to run away. Sometimes these same men find themselves wrestling between the desire to do and be someone other than a preacher because they were not called in the first place. R. W. Schambach, that revered (and proven) revivalist, would often say, "Some are called, some are sent, some just picked up their bags and went." Is it any wonder that thousands leave

the ministry each year due to frustration, burnout, and moral failure? The call of God is what stabilizes the preacher and keeps him going through the difficult times.

Duke K. McCall said, "The one thing no church can stand is a pastor who really wants to be something else. The men who really want out ought to be helped out, for the Christian ministry is no place for a man or woman who wants to be something else. It is a place for those who can give counsel, not the place for men who need counsel." Anyone entering the ministry should know that this is the plan of God for their life and focus on being all that they can be for the glory of the Almighty.

Why are you here? Did you receive the call?

Many people enter the ministry because it looks very simple and easy from a distance. However, reality often hits when the ordination process is completed and they step forward for their first pastoral assignment. Then they realize that ministry is not this glamorous and popular vocation that pays great dividends with little or no stress. Just the opposite is true; while there is sufficient inner satisfaction and numerous joyful experiences, ministry has its share of struggles, difficulties, and challenges. To excel in the ministry a preacher must totally rely on the work of the Holy Spirit to keep him and rejuvenate him on his journey.

Dr. Charles R. Swindoll gives those considering entering the ministry a reality check in his book, Swindoll's Ultimate Book of Illustrations & Quotes:

> WANTED: MINISTER FOR GROWING CHURCH. A real challenge for the right man! Opportunity to become better acquainted with people! Applicant must offer experience as a shop worker, office worker, educator (all levels, including college), artist, salesman, diplomat, writer, theologian, politician, Boy Scout leader, children's worker, minor league athlete, psychologist, vocational counselor, psychiatrist, funeral director, wedding consultant, master of ceremonies, circus clown, missionary, social worker. Helpful, but not essential: experience as a butcher, baker, cowboy, Western Union messenger.

Must know all about problems of birth, marriage, and death; also conversant with latest theories and practices in areas like pediatrics, economics, and nuclear science. Right man will hold firm views on every topic, but is careful not to upset people who disagree. Must be forthright but flexible; returns criticism and backbiting with Christian love and forgiveness.

Should have an outgoing, friendly disposition at all times. Should be captivating speaker and intent listener. Education must be beyond Ph.D. requirements, but always concealed in homespun modesty and folksy talk. Able to sound learned at times but most of the time talks and acts like good-ol' Joe. Familiar with literature read by average congregation.

Must be willing to work long hours, subject to call any time day or night; adaptable to sudden interruption. Will spend at least twenty-five hours preparing sermon. Additional ten hours reading books and magazines. Applicant's wife must be stunning and plain, smartly attired but conservative in appearance, gracious and able to get along with everyone. Must be willing to work in church kitchen, teach Sunday school, baby-sit, run multilith machine, wait tables, never listen to gossip, never become discouraged. Applicant's children must be exemplary in conduct and character; well behaved, yet basically no different from other children; decently dressed.

Opportunity for applicant to live close to work. Furnished home provided; open door hospitality enforced. Must be ever mindful the house does not belong to him. Directly responsive for views and conduct of all church members and visitors, not confined to direction or support from any one person. Salary not commensurate with experience or need; no overtime pay. All replies kept confidential. Anyone applying will undergo full investigation to determine sanity. (Swindoll 1998)

This may seem humorous and a bit farfetched, but in reality, the situation and expectation from members of the congregation and community are the same. Preachers are asked to do the supernatural, live above the angels, overcome every challenge life throws at them, and be the perfect example of a sinless life. They are never to be discouraged, frustrated, or physically tired. The expression, "ministry is no joke!" is a true statement that needs to be seriously examined by all candidates for the office. Apostle Paul said, "But we have this treasure in earthen vessels, that the excellence of the power may be of God and not of us. We are hard pressed on every side, yet not crushed, we are perplexed, but not in despair; persecuted, but not forsaken; struck down, but not destroyed—always carrying about in the body the dying of the Lord Jesus, that the life of Jesus also may be manifested in our body." (2 Corinthians. 4:7-11).

There is a divine purpose in all that the minister of the gospel experiences because God uses the many trials, afflictions, and challenges to prune us, mature us, build balance, internal fortitude, courage, faith, and many other important virtues into these earthen vessels. The key is to see the mighty hand and purposes of God at work in us and for our good during the time of suffering and disappointments. Jesus said, " . . . and every branch that bears fruit He prunes, that it may bear more fruit." (John 15:2b). The profile of a preacher should reflect the very character of Christ and this doesn't come without pruning, struggles, pain, and trials. So we conclude that ministry first starts with the call from God to be a preacher of righteousness; this leads to the process of character development which will result in a fruitful life of ministry if the Holy Spirit is allowed to lead and direct him or her.

CHAPTER SEVEN
Character under Scrutiny

"I have conquered an empire but I have not been able to conquer myself." Peter the Great, Czar of Russia

Robert Freeman says, "Character is not made in a crisis—it is only exhibited". The word character can be defined as the essential features or qualities of an individual. When it comes to the profile of the preacher, having a good, godly character is an essential component of that person's make-up. People are often judged by their actions and words. When a preacher does not reflect the character of Christ, a negative stigma is attached to that individual. It has been reported that D. L. Moody said that character is what you are in the dark. The true person comes out on display when no one is around to see them. The preacher's life must be consistent with his faith or else he will be thought of as a hypocrite.

What are some of the fundamental traits that a preacher should have and why are they so important? In my research, I came across a list of fundamental character traits developed by Bill Gothard[4] on www.billgothard.com

Operational Definitions of 49 Character Qualities

Alertness *vs. Unawareness.* Being aware of that which is taking place around me so I can have the right response to it (Mark 14:38).

Attentiveness *vs. Unconcern.* Showing the worth of a person by giving undivided attention to his words and emotions (Hebrews 2:1).

Availability *vs. Self-centeredness.* Making my own schedule and priorities secondary to the wishes of those I am serving (Philippians 2:20-21).

Boldness *vs. Fearfulness.* Confidence that what I have to say or do is true and right and just in the sight of God (Acts 4:29).

Cautiousness *vs. Rashness.* Knowing how important right timing is in accomplishing right actions (Proverbs 19:2).

Compassion *vs. Indifference.* Investing whatever is necessary to heal the hurts of others (I John 3:17).

4 Bill Gothard is founder and president of the Institute in Basic Life Principles Offsite Link, a nonprofit corporation dedicated to serving youth and families through God-ordained leaders. billgothard.com

Contentment *vs. Covetousness.* Realizing that God has provided everything I need for my present happiness (I Timothy 6:8).

Creativity *vs. Underachievement.* Approaching a need, a task, an idea from a new perspective (Romans 12:2).

Decisiveness *vs. Double-mindedness.* The ability to finalize difficult decisions based on the will and ways of God (James 1:5).

Deference *vs. Rudeness.* Limiting my freedom in order to not offend the tastes of those whom God has called me to serve (Romans 14:21).

Dependability *vs. Inconsistency.* Fulfilling what I consented to do even if it means unexpected sacrifice (Psalm 15:4).

Determination *vs. Faintheartedness.* Purposing to accomplish God's goals in God's time regardless of the opposition (II Timothy 4:7-8).

Diligence *vs. Slothfulness.* Visualizing each task as a special assignment from the Lord and using all my energies to accomplish it (Colossians 3:23).

Discernment *vs. Judgment.* The God-given ability to understand why things happen (I Samuel 16:7).

Discretion *vs. Simplemindedness.* The ability to avoid words, actions, and attitudes which could result in undesirable consequences (Proverbs 22:3).

Endurance *vs. Giving up.* The inward strength to withstand stress to accomplish God's best (Galatians 6:9).

Enthusiasm *vs. Apathy.* Expressing with my soul the joy of my spirit (I Thessalonians 5:16, 19).

Faith *vs. Presumption.* Visualizing what God intends to do in a given situation and acting in harmony with it (Hebrews 11:1).

Flexibility *vs. Resistance.* Not setting my affections on ideas or plans which could be changed by God or others (Colossians 3:2).

Forgiveness *vs. Rejection.* Clearing the record of those who have wronged me and allowing God to love them through me (Ephesians 4:32).

Generosity *vs. Stinginess.* Realizing that all I have belongs to God and using it for His purposes (II Corinthians 9:6).

Gentleness *vs. Harshness.* Showing personal care and concern in meeting the need of others (I Thessalonians 2:7).

Gratefulness *vs. Unthankfulness.* Making known to God and others in what ways they have benefited my life (I Corinthians 4:7).

Hospitality *vs. Loneliness.* Cheerfully sharing food, shelter, and spiritual refreshment with those whom God brings into my life (Hebrews 13:2).

Humility *vs. Pride.* Recognizing that it is actually God and others who are responsible for the achievements in my life (James 4:6).

Initiative *vs. Unresponsiveness.* Recognizing and doing what needs to be done before I am asked to do it (Romans 12:21).

Joyfulness *vs. Self-pity.* The spontaneous enthusiasm of my spirit when my soul is in fellowship with the Lord (Psalm 16:11).

Justice *vs. Fairness.* Personal responsibility to God's unchanging laws (Micah 6:8).

Love *vs. Selfishness.* Giving to others' basic needs without having as my motive personal reward (I Corinthians 13:3).

Loyalty *vs. Unfaithfulness.* Using difficult times to demonstrate my commitment to God and to those whom He has called me to serve (John 15:13).

Meekness *vs. Anger.* Yielding my personal rights and expectations to God (Psalm 62:5).

Obedience *vs. Willfulness.* Freedom to be creative under the protection of divinely appointed authority (II Corinthians 10:5).

Orderliness *vs. Disorganization*. Preparing myself and my surroundings so I will achieve the greatest efficiency (I Corinthians 14:40).

Patience *vs. Restlessness*. Accepting a difficult situation from God without giving Him a deadline to remove it (Romans 5:3-4).

Persuasiveness *vs. Contentiousness*. Guiding vital truths around another's mental roadblocks (II Timothy 2:24).

Punctuality *vs. Tardiness*. Showing high esteem for other people and their time (Ecclesiastes 3:1).

Resourcefulness *vs. Wastefulness*. Wise use of that which others would normally overlook or discard (Luke 16:10).

Responsibility *vs. Unreliability*. Knowing and doing what both God and others are expecting from me (Romans 14:12).

Reverence *vs. Disrespect*. Awareness of how God is working through the people and events in my life to produce the character of Christ in me (Proverbs 23:17-18).

Security *vs. Anxiety*. Structuring my life around that which is eternal and cannot be destroyed or taken away (John 6:27).

Self-Control *vs. Self-indulgence*. Instant obedience to the initial promptings of God's Spirit (Galatians 5:24-25).

Sensitivity *vs. Callousness*. Exercising my senses so I can perceive the true spirit and emotions of those around me (Romans 12:15).

Sincerity *vs. Hypocrisy*. Eagerness to do what is right with transparent motives (I Peter 1:22).

Thoroughness *vs. Incompleteness*. Knowing what factors will diminish the effectiveness of my work or words if neglected (Proverbs 18:15).

Thriftiness *vs. Extravagance*. Not letting myself or others spend that which is not necessary (Luke 16:11).

Tolerance *vs. Prejudice.* Acceptance of others as unique expressions of specific character qualities in varying degrees of maturity (Philippians 2:2).

Truthfulness *vs. Deception.* Earning future trust by accurately reporting past facts (Ephesians 4:25).

Virtue *vs. Impurity.* The moral excellence and purity of spirit that radiate from my life as I obey God's Word (II Peter 1:3).

Wisdom *vs. Natural Inclination.* Seeing and responding to life's situations from God's frame of reference (Proverbs 9:10).

These very traits were displayed in the life of Christ and it is vitally important that the preacher seeks to develop the ones missing from his life. The preacher's character is under scrutiny because people are observing his life, looking for a level of consistency between what he preaches and how he lives. It is not that the preacher should try to live up to the expectations of the people, but rather he should be a model or example for them to follow as he follows Christ. We are what we speak and we speak what we truly are. Jesus said, "Not what goes into a man that defiles a man; but what comes out of the mouth, that defiles a man." (Matthew 15:11). It is imperative that the preacher be every bit of what he preaches because the eyes of the world are watching.

CHAPTER EIGHT

Inner Disciplines of the Preacher

"If my religion's not all that it ought to be. The trouble's not with God, the trouble's with me. Anonymous

first became aware of the expression, "Inner Disciplines" some years ago at a pastors' breakfast meeting with Mike Brown. Though the expression was new to me, the concept and the content were familiar having read the works of Andrew Murray, E. M. Bounds, Brother Lawrence, and others. I refer to this as the deeper life or the surrendered life. When I talk about inner discipline, I include meditation, prayer, solitude, quietness, fasting, personal sacrifice, devotional time, and other things that deeply affect our spiritual development. At the heart of these disciplines is the inner transformation of the preacher. God desires to change each of us into the image of His Son, and this cannot happen unless we allow the Holy Spirit to peel away the outer layers of our fleshly nature.

I would like to point out three reasons why this area warrants close attention if the preacher is going to be effective and have power with God. First of all, the power of God flows out of a life of purity. Secondly, a disciplined inner life sensitizes the human spirit to hear the voice of God clearly. Thirdly, spiritual disciplines empower the preacher to overcome his carnal struggles.

Application of these disciplines helps us to grow in grace while developing an appetite for the spiritual. Richard Foster begins the first chapter of his book *Celebration of Discipline* with these statements, "Superficiality is the curse of our age. The doctrine of instant satisfaction is a primary spiritual problem. The desperate need today is not for a greater number of intelligent people, or gifted people, but for deep people." The reference to "deep" means having a level of maturity and spirituality, not prone to fleshly indulgence or selfish ambition, but a life surrendered to Christ-centered living. This type of living involves prayer, meditation, solitude, personal worship, studying the Word, and a degree of sacrifice.

It is difficult to find deep saints, deep preachers, and deep believers in society today. The primary reason is the fact that we love things that make us comfortable and secure. We like things that appeal to our flesh. But if we are going to grow in our walk with God and develop a Christ-centered perspective on life it will only come as we seek hard after God and this is done through the disciplines. Following are three reasons why the preacher needs to embrace the inner disciplines:

1. The power of God only flows out of a life of purity—A life of purity is characterized by a life that is pleasing to God. The preacher that is led and controlled by the Holy Spirit lives by the conviction of the Word of God. Though not perfect, there is a conscious effort to live a holy life pleasing to God. The preacher understands that the impact of his preaching and ministry is a result of the Spirit working in and through him. A life void of personal holiness will be consumed with self-centered motivation, fleshly ambition, and carnal activities that often result in moral failure. The Bible says, "Nevertheless the solid foundation of God stands, having this seal: the Lord knows those who are His, and let everyone who names the name of Christ depart from iniquity." (2 Timothy 2:19).

2. A disciplined inner life sensitizes the human spirit to hear the voice of God clearly—Our world is filled with noise, and the average person is so programmed to function with a certain element of noise that the absence of it makes the individual disquieted. Most people are afraid of silence, but in order to hear the voice of the Holy Spirit our inner man needs to learn how to be still and listen for that still small voice. (1 King 19:12).

The subject of solitude is of vital importance when it comes to hearing the voice of God. Yet, many preachers are clueless about the value of this type of spiritual activity. The gospel reveals the practice of this ritual in the life of Christ when He would spend all night on the mountain praying in solitude. Solitude is more than a place; it is a state of mind and heart. It is the creation of a portable sanctuary in the heart. It is learning how to be still in the middle of noise, it is the quieting of our heart so that fellowship and intimacy with God can be developed. A keen awareness of God's presence is the result of learning how to enjoy solitude.

3. Spiritual discipline empowers the preacher to overcome his carnal struggles. A disciplined mind will think clearer, perceive sharper, and analyze more correctly. The power that was promised on the day of Pentecost came upon mankind and changed the apostles forever (Acts 2). They went from being timid, fearful, and weak, to being bold, courageous, and fearless after they were baptized in the Holy Spirit. It was a life of discipline that kept the apostles moving in that power. Not only was this

power made available for them to preach, but it also empowered them to experience internal victory over their flesh . . . "Walk in the Spirit and you will not fulfill the lust of the flesh." (Galatians 5:16). Spiritual discipline teaches the preacher to maintain his alertness and power. He is able to live in the flow of renewal each day as he practices the presence of God.

Understanding the Spiritual Disciplines

The subject of spiritual discipline is of vital importance to all believers, but especially those in the five-fold ministry. These leaders play a very strategic role in the development and expansion of the kingdom of God. Therefore it is imperative that they be in a spiritual position to hear God and that clearly. God is always speaking, but we are not always listening for various reasons. Sometimes, the preacher traffics too much in the arena of carnality. When this is the case they clog up their spiritual ears making it difficult to hear from heaven. The practice of spiritual disciplines takes them to a place where the Spirit of God dwells and where spiritual transformation is evident in their lives. Let us examine a few of these activities.

Prayer-Jeremiah 33:3 says, "Call to Me, and I will answer you, and show you great and mighty things, which you do not know." This passage captures the essence of prayer at its root. Prayer is calling out to our Creator with the expectation that we will be heard and the answer will come in some form. This activity seems easy and elementary at first, but there is also the profound side that requires discipline, energy, and commitment.

I view the process of prayer in three ways: duty, desire, and delight. This process is progressive in scope and intriguing to the mind. It challenges the flesh of a believer to stop it, delay it, or continue it. In his book entitled, *Ordering your Private World*, Gordon MacDonald shares this important observation of why believers see prayer as a real challenge. Mr. McDonald says,

> . . . praying in any meaningful way militates against virtually everything within our natural selves and is foreign to what our culture teaches us as a way of life. Few people realize how brainwashed we are by messages bombarding our private world every day, telling us that anything of a spiritual nature is really

a waste of time. From our earliest years we are subtly taught that the only way to achieve anything is through action. But prayer seems to be a form of inaction. To the person with a disordered private world, it does not seem to accomplish anything.[5]

We can often tell the value of an activity based on the attack from the enemy. Because prayer is such a powerful tool given to the believer, Satan will go to great length to discourage the believer from using this valuable tool. The preacher must understand that prayer is the door to spiritual power with God and the means by which God communicates with His children. I have read scores of books on prayer and studied the lives of great men and women of God both past and present and the one common thread that runs through all their lives is a commitment to prayer. I have been greatly aided by reading about the prayer life of men like Brother Lawrence, A.W. Tozer, Andrew Murray, Watchman Nee, Smith Wigglesworth, John G. Lake, John Wesley, William Carey, and many others. Each time I read one of these books I come away with a greater thirst for prayer and a deeper consciousness of the holiness of God. Let us examine the process of prayer a little more closely:

Prayer is a "**duty**" that all believers must take seriously because our Master made it very clear as to the attitude we should have about prayer; " . . . men always ought to pray and not to lose heart." Luke 18:1. It is our duty to pray; we are commissioned to pray. The word duty means, "what one is morally or legally bound to do; actions required by one's job or position." The preacher must see prayer as a matter of duty because His boss says it is. Richard Foster believes the following, "For those explorers in the frontiers of faith, prayer was no little habit tucked away onto the periphery of their lives; it was their lives. It was the most serious work of their most productive years."[6] He mentions the prayer habits of great men of faith like Adoniram Judson who he said, "sought to withdraw from business and company seven times a day in order to engage in the holy

5 Gordon McDonald, Ordering your Private World, Thomas Nelson Publishers
6 Richard J. Foster, Celebration of Discipline: The Path to Spiritual Growth, Harper Collins 1978, p34

work of prayer. He began at dawn; then at nine, twelve, three, six, nine, and mid-night he would give time to secret prayer."[7] Foster included the habits of John Hyde of India who made prayer such a dominant characteristic of his life that he was nicknamed "Praying Hyde." These preachers saw prayer as their spiritual duty before their Creator. Prayer was necessary for their very existence.

Prayer is "**desire**"—craving, longing, yearning, aspiration, want, and hunger. The habit of prayer by way of duty leads to desire. The more we pray, the more we want to pray. The more a person indulges in something, the more an appetite is developed that drives that desire. Prayer can be an addicting activity that places a demand on our spirits. Daniel was a man given to both the duty of prayer and a strong desire to pray. The Bible tells us that " . . . in his upper room, with his windows open towards Jerusalem, he knelt down on his knees three times that day, and prayed and gave thanks before his God, as was his *custom since early days.*" (Daniel 6:10 italics added). As an exile in Babylon, for many years from his youth, Daniel tenaciously clung to his practice of prayer in spite of being in a pagan culture. He came to Babylon with the discipline of prayer and he continued to practice it throughout his life. Martin Luther declares, "I have so much business I cannot get on without spending three hours daily in prayer"

Many years ago I was invited to preach for the Presbyterian Church in Seoul, South Korea. I was very excited about the opportunity to minister the word of God in that country, but with my excitement came a bit of apprehension because I was aware of the dedication of the believers to prayer in that country. To the average Korean believer, prayer was not a neglected activity as it is with many believers in the West. Korean believers take prayer very seriously; it is their duty and desire to pray and that they do constantly.

While in Korea, our team wanted to visit the famous Prayer Mountain where hundreds of believers would gather daily to pray year round. What we discovered will never leave our minds. We spent one hour and a half with Dr. Paul Cho, pastor of the Yoido Full Gospel Church, (the largest church in the world with 800,000 members at one location at that time). After our

[7] Ibid, p 34

meeting, which included prayer and encouragement, we went to take the bus that left from the church hourly to ascend to Prayer Mountain. We were shocked at what we saw; the line was very long and there were people with young children, teenagers, and senior citizens. When the bus arrived they started to push to get into the bus with such a passion you would think that they were late to catch a cruise ship or a plane to the Caribbean for a vacation. In America we had never seen believers act with such desire and passion to attend a prayer meeting. We were told that many of them were going to spend a few days to a week in prayer and fasting. They had sleeping bags, blankets, pillows, bottles of water, and their Bibles. When we finally arrived on the mountain, we were again surprised by the sight. There were a few buildings with large chapels filled with hundreds of people laying on the floor praying, singing, reading their Bibles, and crying out to God. Next we went further up the mountain to the prayer caves built into the hill with concrete. Each cave was about the size of a small doghouse and could hold two people at the most. There were hundreds of them with only a few vacancies. I might add that the weather was in the 20's and we were freezing with our gloves, boots, and heavy coats. While we complained about the cold, the Korean believers were praying in those small kennels in the cold.

We observed a people that had discovered the secret of prayer, duty and desire. Dr. Cho said, "As a pastor, I have learned from the beginning of my ministry that the only way to cause my members to want to pray is to pray myself. If I did not have a life of prayer, I would not have had a praying church, and I certainly would not be in the midst of revival." Our team spent over an hour talking with him about his ministry and the prayer revival that is spreading around the world and he attributes the outpouring of God's Spirit to the ministry of intercession that so many are engaged in as prayer becomes a desire that makes them hungry for God.

Prayer is "**delight**"—enjoyment, pleasure, fascination, joy. Often we think of prayer as a discipline or duty to be carried out in order to please God or to get our prayers answered. However, prayer is more than just a religious activity, it goes beyond duty and desire, it brings pleasure. The Bible says of Jesus, "Now in the morning, having risen a long while before daylight, he went out and departed to a solitary place; and there he prayed." (Mark 1:34).

Prayer for Jesus was more than a religious activity performed daily to stay in touch with his heavenly Father. Jesus took pleasure in meeting with his Father, and we see a track record of his prayer habits throughout the gospels. To many of us, prayer is a challenging activity that wears on our flesh. Therefore, we set aside a few minutes to meet our religious obligation and to ease our consciences. Prayer is a duty and as with any duty it must be carried out. But Jesus had such a relationship with his Father that prayer consumed him, much like the feelings experienced between two new lovers when they hear each other's voice on the phone. There is a feeling of joy and excitement just to hear from each other; Jesus felt the same way. Having lived with his father before time existed, separation for him was difficult, but he knew that he was a man on a mission and once the mission was over things would go back to their original state. But until then, he had to use the vehicle of prayer to enjoy oneness with his father.

How can a believer achieve such a relationship with God? Is it even possible? The answer is yes, one can. David Brainerd's life was devoted to prayer and he said this in his journal, "I love to be alone in my cottage, where I can spend much time in prayer." Like Jesus, he enjoyed meeting with his heavenly father. For him, prayer had moved from duty and desire, and now it was delightful for him. Well, I must confess that I enjoy praying; however, to have such a delight gives me something to shoot for in my spiritual growth. We surmise that the Apostle Paul also viewed prayer as a delight when we read in the book of Ephesians of his love and desire to pray for the saints. He lived on his knees. Prayer for the apostle Paul was as natural as breathing is to any human.

Throughout history, many servants of the Lord have discovered the secret of prayer and have left words of encouragement to ignite our souls. The following quotes on prayer are from great men of the Christian faith. Let us meditate on these words of encouragement from these men of faith.

> **John Bunyan**, "Prayer is a sincere, sensible, affectionate pouring out of the soul of God, through Christ in strength and assistance of the Spirit, for such things as God has promised."[8]

[8] Frank S. Mead, 12,000 Religious Quotations, (Baker Book House Company, 1989) p. 338.

Abraham Lincoln, "I have been driven many times to my knees by the overwhelming conviction that I had nowhere else to go."[9]

John Newton, "Thou art coming to a King, large petitions with thee bring for his grace and power are such, none can ever ask too much."[10]

St. Francis de Sales, "He prays well who is so absorbed with God that he does not know he is praying."[11]

Henry Ward Beecher, "Prayer covers the whole of a man's life. There is no thought, feeling, yearning, or desire, however low, trifling, or vulgar we may deem it, which, if it affects our real interest or happiness, we may not lay before God and be sure of sympathy. His nature is such that our often coming does not tire Him. The whole burden of the whole life of every man may be rolled on to God and not weary him, though it has wearied the man."[12]

Solitude—Mark 1:35 "Now in the morning, having risen a long while before daylight, He went out and departed to a solitary place; and there he prayed." Most people will attest to the fact that we are people of movement, activities, noise, and action. We keep the television going at all times even if we are preoccupied with other activities; the radio is our partner when we are in our vehicles, and any leisure moment is spent with a CD playing in the background. We like noise; we are conditioned to have noise with us, around us, and never too far from us. There is something about stillness or quietness that irritates us, intimidates us, and that just drives us out of our minds. From the preacher to the postal worker, noise is a part of the daily routine. We often fail to see the value of stillness; we think that only busy people accomplish things and stillness is a waste of time. Nothing

[9] Ibid., p.342
[10] Ibid., p345
[11] Ibid., p340
[12] Ibid., p337

could be further from the truth. As a matter of fact, it is quite the opposite. Jesus demonstrated to the disciples the value and importance of being still. He made solitude part of his daily routine. His prayer time was spent in stillness, praying, and meditation. Why else would he go looking for a solitary place in the morning to pray? Jesus knew the value of being alone with God to quiet the inner noise of the mind so that he could hear his heavenly Father.

Solitude is a very important part of spiritual formation for the preacher and all who would follow in the footsteps of Christ. It is integral to developing the mind to hear the voice of God.

Richard J. Foster, makes the following statement on the subject:

> Solitude is more a state of mind and heart than it is a place. There is a solitude of the heart that can be maintained at all times. Crowds, or the lack of them, have little to do with this inward attentiveness. It is quite possible to be a desert hermit and never experience solitude. But if we possess inward solitude we do not fear being alone, for we know we are not alone. Neither do we fear being with others, for they do not control us. In the midst of the noise and confusion we are settled into a deep inner silence. Whether alone or among people, we always carry with us a portable sanctuary of the heart.[13]

The key to solitude is the attitude one takes coupled with the discipline of learning to be still. How can preachers hear from heaven what to preach if they are always moving, talking, fellowshipping, and being busy. Jesus is our primary example and as we watch Him, we learn how to be still as a practice. Jesus spent forty days in the wilderness before he entered into public ministry (Matthew 4:1-11). After his conversion experience, the Apostle Paul went off into the desert of Arabia, to learn about his new found faith (Galatians 1:17). And then there is also John the Baptist, another wilderness dweller, who could hear the voice of God as to what

13 Richard J. Foster, Celebration of Discipline (HarperCollins Publishers, Inc, 1978) pp 96

his assignment would be in life. He prepared the hearts of the people so that they would be ready to receive the message of Christ when He started his ministry. As I conclude the subject of solitude, I would like to point out that to really appreciate the importance of the spiritual disciplines one must be spiritually mature. The average preacher has no appreciation or fascination with solitude. It is seen as a waste of time or an activity that does not yield much in the way of preaching. But it was the great Albert Einstein who said, "Solitude is painful when one is young, but delightful when one is more mature."

Meditation—"I will meditate on your precepts, and contemplate your ways" (Psalm 119:15). "This book of the Law shall not depart from your mouth, but you shall meditate in it day and night, that you may observe to do according to all that is written in it . . ." (Joshua 1:8).

These passages point out the importance of meditation in the life of the believer. Our spiritual success is linked directly to speaking the word of God and meditating on it as well. Isaac Taylor says, "A man of meditation is happy, not for an hour or a day, but quite round the circle of all his years." Let us explore this subject and see how the preacher can enhance the quality of his spiritual life and develop a habit that will help in preaching the word more effectively.

Webster's dictionary defines "meditation" as a deep thought or serious contemplation. Random House Word Menu defines it as a devotional exercise that involves contemplation and concentration. It is a spiritual and mental discipline dealing with sustained introspection. Judging from these definitions we get the idea that meditation is an activity involving our body, mind, and emotions. In order for meditation to be meaningful, quietness and/or stillness is required. Before I deal with the benefits on the body, mind, and emotions, let me share a very interesting statement from Richard Foster on the subject. He makes the following observation, "In contemporary society our adversary majors in three things: noise, hurry, and crowds. If he can keep us engaged in 'muchness' and 'manyness' he will rest satisfied . . . if we hope to move beyond the superficialities of our culture, including our religious culture, we must be willing to go down

into the recreating silences, into the inner world of contemplation. In their writings all the masters of meditation beckon us to be pioneers in this frontier of the Spirit. Though it may sound strange to modern ears, we should without shame enroll as apprentices in the school of contemplative prayer."[14]

Meditation is a missing art from the lives of the modern day clergy. Most often view ministry as activities and movements, not stillness and silence. But in order for the preacher to rise to the heights of the Spirit, and encounter the Holy, he will have had to develop his inner discipline and master the art of meditation.

What are the benefits of mediation? This exercise is mentioned all over the scriptures as an activity connected with our spiritual walk. The Lord instructed Joshua to meditate on His word "day and night" and it would make his way prosperous and he would have good success. Isaac made meditation a part of his afternoon routine, "And Isaac went out to meditate in the field in the evening . . ." (Genesis 24:63). Apostle Paul told the church at Philippi to meditate on "whatever things are true, whatever things are noble, whatever things are just, whatever things are pure . . . meditate on these things" (Philippines 4:8). Asaph recorded, "I call to remembrance my song in the night; I meditate within my heart, and my spirit makes diligent search." (Psalm 77:6). Meditation is a spiritual activity that will help the preacher achieve a greater level of intimacy in his relationship with his God. Meditation benefits the mind, body, emotion, and spirit:

- Meditation and the body—it reduces tension in the muscles, reduces chronic pain, and it reduces the effects of stress.

- Meditation and the mind—relaxes the mind, improves memory, makes the mind sharper and clearer, and it increases creativity.

- Meditation and the emotions—helps reduce negative emotions such as depression and anxiety.

[14] Ibid,.p15

- Meditation and the human spirit—gives the believer a greater sense of purpose, insight into one's true identity, and it enhances the relationship between the believer and God by making the human spirit more alert and sensitive to the Holy Spirit's leading. It sanctifies the imagination and aids in exposing deceptive practices by the enemy.

On a final note, our meditation must have an object. The object is God in His glory. As one meditates on the promises of God in the scriptures, it is the meaning behind the promise in the Bible to which we must give our attention. Before we can focus, we must clear the mind of the many fruitless thoughts that invades it. This is a constant battle that requires concentration and mental discipline. It is not easily achieved the first time that a person begins the process of meditation. Progression in the spiritual life evokes a fight with the mind and the flesh.

Discouragement has a way of trying to stop us before we can dive beneath the shallow waters of our carnality into the deep richness of God's revelation. Perseverance is the key. This exercise will take us to the end of our earthly life. Therefore, to expect to achieve this discipline in a few sessions will profit us very little. As we focus on the scriptures the mind is saturated with the promises. It has been stated that, whatever you hold in your mind will tend to occur in your life. Therefore, meditation will cause our minds to be in tune with the mind of Christ as we make the word of God our focal point. And when we believe, our faith will be released resulting in the manifestation of the answer.

Worship—"Oh come, let us worship and bow down; let us kneel before the Lord our Maker. For He is our God, and we are the people of His pasture, and the sheep of His hand." (Psalm 95:6, 7). There are two types of worship, corporate worship and personal worship. I would like to focus on the discipline of *"personal worship."* Every preacher should have a strong worship experience with the Lord. As a matter of fact, it should be seen as a personal responsibility. But because we live in such a microwave society, many have developed a plug and go mentality. I don't know the statistics, but I venture to say that many preachers don't have a personal

worship life. They live in the "up and out" reality of daily activities that often drives them from one appointment to the next. They may excel in corporate worship, but to meet with God in the cool of the day is nonexistent. Why is there a resistance to such a valuable experience? There are a few reasons for this neglect; first of all, it is a spiritual activity that irritates the flesh and challenges the supremacy of an earthly kingdom. Secondly, it takes time and effort to engage the mind in spiritual things for even a few minutes. Thirdly, some preachers feel that personal worship is not really necessary for their spiritual growth.

What is personal worship? Richard Foster says, "Worship is the human response to the divine initiative, the devotion to and exaltation of God. It is surrendering one's will and purpose to the Spirit of God in a celebratory and adoring way." William Temple says the following, "To worship is to quicken the conscience by the holiness of God, to feed the mind with the truth of God, to purge the imagination by the beauty of God, to open the heart to the love of God, to devote the will to the purpose of God."[15] Preachers should not neglect personal worship, but rather make it a part of their daily routine. Worship can be conducted while driving, jogging, shopping, cutting the lawn, painting the house, fixing the car, or playing golf. It is a condition of the heart that seeks expression in solitude or verbal praise.

I have briefly examined four spiritual disciplines (prayer, solitude, meditation, worship) that I feel are important to the preacher's spiritual wellbeing. Although there are many more of equal values, I believe that these four will have a positive impact on the preacher's ability to prepare the content, preach, and deliver the message in a manner that achieves maximum impact.

[15] Ibid., p. 158

The Relevance of Hermeneutics and Homiletics

"The sermon is the house; the illustrations are the windows that let in the light." Charles H. Spurgeon

According to the American Heritage Dictionary "Hermeneutics" is defined as "the theory and methodology of interpretation, especially of scripture text." When it comes to the relevance of hermeneutics as it relates to preaching, one must have a keen understanding of the biblical text in order to preach with authenticity and scriptural soundness. The Bible says of King Solomon, " . . . because the preacher was wise, he still taught the people knowledge; yes, he pondered and sought out many proverbs. The preacher sought to find many acceptable words . . . words of truth." (Ecclesiastes 12:9, 10). Solomon's thirst for knowledge and the proper usage of the scripture led him to write from the perspective of both the student and the teacher. He did not just take things at face value, but rather he did his research and came to his own conclusion. When the apostle Paul instructed his apprentice Timothy to "study to show himself approved unto God, a workman that needed not to be ashamed, rightly dividing the word of truth" (II Tmothy 2:15), he wanted him to have a personal knowledge of the scripture. This type of knowledge and understanding cannot be obtained without embracing the subject of hermeneutics. For the preacher to be able to handle the scriptures skillfully and deliver sound messages that are void of false interpretation requires solid exegesis to analyze the text within its context.

Why is it important to combine hermeneutics with homiletics?

Effective preaching always involves the usage of hermeneutics and homiletics. The two are inseparrable. They can function independently, but not very well. Having homiletics without hermeneutics is like cooking meat without seasoning, it can be eaten, but it will have a bland taste. It is through the system of hermeneutics that the preacher is able to analyze and dissect the text. The former focuses on understanding and interpreting the text while the latter puts it in the vehicle that will best communicate it in a systematic way. True hermeneutics will view the scripture from its historical, geographical, and cultural positions thus making it easy to apply it correctly when preaching.

What is the difference between hermeneutics and exegesis?

Exegesis researches, examines, and probes the written text, while hermeneutics focuses on the interpretive process as it relates to the culture and practices of the people. Most words have multiple meanings and usage and the preacher must understand the background and culture as well as the way the people of that time used the words. This information can only be ascertained through exegesis, applying the hermeneutical process. Exegesis will take the word apart and look at its root meaning and origin. In the book, Contemporary Biblical Interpretation for Preaching, the writer says, "the word 'prophet' means one who foretells the future. Thus prophecy is prediction of future events. A simple word study reveals that when chopped in half, the Greek word "prophet" is composed of two parts which mean "to speak" and "for." A prophet is one who speaks for someone else, notably God. A classic prophet speaks for God, interpreting the meaning of life and history from the divine perspective. On the basis of critical interpretation, the prophet may conjecture that certain future trends or events may take place, but the basic function of prophecy is interpretation."[16]

Another example that I would like to share focuses on the word "Power" in the New Testament. The meaning changes within different passages. In John 1:12 the word "power" means "right" or "privilege"—"but as many as received him, to them he gave the 'right' to become sons of God." The word 'right' means that they have the privilege to be a part of the family of God or the "freedom" to belong. This same English word means something totally different in Acts 1:8, "But you shall receive 'Power' when the Holy Spirit has come upon you . . ." The usage of the word here means "might, force, strength" to preach the gospel and be a positive witness. Throughout the Bible the same words when used in different places will have different meanings based on the cultural practices and root meaning.

Sermon preparation requires hard and tedious work and calls for mental discipline and attention to detail. The preacher must have the mind of an investigative reporter. After the text is analyzed and actualized,

[16] Ronald J. Allen, Contemporary Biblical Interpretation for Preaching, Judson Press, Valley Forge, PA 1984 pp 42

the preacher must be skilled enough to make the transition to present day conditions as well as the personal application to the members of the congregation.

The preacher without schooling in this area will have a challenge preaching in the twenty-first century church because of the mindset of the people in this generation. Even Christians are cynical, sarcastic, and fill with unbelief. If the preacher is not knowledgeable and capable, his preaching will fall on deaf ears as the audience falls asleep in the pews, due to a lack of comprehension or the preacher's inability to make it have practical meaning.

CHAPTER TEN

Appearance and Presentation Matters

"When she saw the accommodation for his officials, the organization of his staff and how they were dressed . . . she was quite overwhelmed." 1 Kings 10:5

From a distance, preaching appears to be an easy activity that requires minimal communication skills. After all, the preacher only needs a Bible, a suit, and an idea to begin. Nothing could be further from the truth. To be a good preacher one needs to have a solid biblical knowledge and understanding as well as the ability to communicate that knowledge for maximum impact. Apart from having a decent skill level, it is important to have a stage presence. Why is that important? It is important because you become the object of everyone's attention for thirty to sixty minutes. All eyes will be on the preacher during his sermon.

There are several reasons why appearance matters during the preaching;

- Appearance matters because the congregation expects the preacher to look a certain way based upon the church's cultural norm.

 a. Conservative congregations—the church will expect the preacher to wear a suit.

 b. Conservative, traditional congregations—the church will expect the preacher to be dressed in a robe and or clergy collar.

 c. Contemporary congregations—the church will expect the preacher to dress smart causal. As a matter of fact wearing a suit and tie or clergy robe would seem strange and out of place.

- Appearance matters because the preacher is called to a holy, high, and sacred office, and it is important that they look their best as they represent the office of a preacher.

- Appearance matters because the congregation expects the preacher to be well groomed because he is performing a sacred duty. Judges wear robes, police officers wear uniforms, doctors wear white smocks; they are expected to because it identifies their vocation and responsibilities. So the preacher should look and dress the part.

- The Queen of Sheba was overwhelmed by the organization and order that she observed in King Solomon's temple. His staff wore certain uniforms, that identified their responsibilities, and they served in a systematic and efficient way. Their appearance made a positive impression on the Queen of Sheba and the preacher that is dressed appropriately will also leave a lasting impression on the audience.

Now there is one more point that I would like to state concerning the appearance of the preacher. It is possible to be over dressed to the point that it becomes a distraction instead of an attraction. If the preacher wears colors that are too "loud" i.e. colors that make him the object of fascination instead of listening to the message the audience will be caught up in his attire. Moderation and wisdom are always recommended so that the focus is on the content of the message and not the appearance of the messenger.

The Value of a good Presentation

I have recently put together my list of what I refer to as the "Beatitudes for Ministry." It states, "Blessed is the minister who shows up, speaks up, and shuts up; they will never lack opportunities for ministry." This might seem a bit humorous, but preaching is more than showing up and opening our mouths, it requires thought, insight, creativity, and skill. The preacher must know how to connect with his audience and understand how to present the message in such a way that will leave the people wanting more. The preacher must know how to conduct himself on the stage behind the pulpit. Effective communicators not only have a way with words, but they know how to present their materials in a way that captivates their audience. Their effectiveness is seen in the way they use their voice tones, hand gestures, pauses, and eye contact. Couple that with eloquence of speech and scriptural knowledge and you will have a fascinating preacher. That is what normally attracts people to one preacher over another.

For the most part some preachers are not interested in raising the bar of their communication skill level and so they fail to attract people that

would like to listen to them preach. It is amazing how few even stop to think about why they are so unappealing. They often blame the people rather than doing self-inspection. As preachers, who have been called to proclaim the unadulterated gospel, the Lord desires that we grow in our gifts and calling and improve the way we share the good news. Our motivation should always be to please the Lord by doing the best we can at fulfilling each assignment. Yes, appearance matters!

CHAPTER ELEVEN

Preaching, Teaching, & Exhorting

"God . . . deigns to consecrate to himself the mouths and tongues of men in order that his voice may resound in them."
John Calvin

There is a major difference between preaching, teaching, and exhorting. Some people believe that they are all the same exercise using different names. However, any astute student of the Bible would know that there is a difference between each of these methods of communicating the scriptures.

1. What is preaching? Preaching is the proclamation of divine truths, the verbal publishing of the word of God. Preaching is an acquired skill that is achieved and retained by hard work, self discipline, continuous practices and regular revision of homiletical procedures. Matthew 11:1—"Now it came to pass, when Jesus finished commanding His twelve disciples, that He departed from there to teach and to preach in their cities." Luke 4:43—"But He said to them, "I must **preach** the kingdom of God to the other cities also, because for this purpose I have been sent." Acts 8:5—"Then Philip went down to the city of Samaria and preached Christ to them."

 The Bible mentions the difference between preaching, teaching, and exhorting by using them together in certain passages of scripture to describe distinct activities 1 Timothy 6:2/ Titus 1:9.

2. Teaching is the ability to impart knowledge or skill; to give instruction. It is the methodical instruction in a specific subject or area. The ability to explain and break down the subject matter in a simplistic manner for the purpose of comprehension. To cause to learn by example or experience. Matthew 7:28-29—"And so it was, when Jesus had ended these sayings, that the people were astonished at His teaching, for He taught them as one having authority, and not as the scribes." John 7:14-15—"Now about the middle of the feast Jesus went up into the temple and taught. And the Jews marveled, saying, "How does this Man know letters, having never studied?" Acts 18:24-25—"Now a certain Jew named Apollos, born at Alexandria, an eloquent man *and* mighty in

the Scriptures, came to Ephesus. This man had been instructed in the way of the Lord; and being fervent in spirit, he spoke and taught accurately the things of the Lord, though he knew only the baptism of John."

3. Exhorting means to admonish earnestly, to make urgent appeal. The ability to apply biblical truths for the purpose of encouragement and comfort. Romans 12:8—"he who exhorts, in exhortation; he who gives, with liberality; he who leads, with diligence; he who shows mercy, with cheerfulness." Acts 14:21-22—"And when they had preached the gospel to that city and made many disciples, they returned to Lystra, Iconium, and Antioch, ²² strengthening the souls of the disciples, exhorting *them* to continue in the faith, and *saying,* "We must through many tribulations enter the kingdom of God." Acts 15:32—"Now Judas and Silas, themselves being prophets also, exhorted and strengthened the brethren with many words."

When preparing to preach or teach the preacher or instructor must have a wide knowledge and understanding of their subject. Then the material must be presented in a systematic way for the purpose of understanding and application.

Exhortation is often done by inspiration and does not necessarily need extensive preparation. For some people it is a gift from God. People with the gift of exhortation are very comfortable being extemporaneous. They normally possess a vast knowledge and understanding of the scriptures and they know the gentle voice of the Holy Spirit. They speak as they are being led by the inner voice of the Holy Spirit. The mark of an exhorter is seen in their message. Their motivation is to build up and encourage the church, not to expose sin or pronounce judgment.

CHAPTER TWELVE
Monday Morning Blues

"Shame arises from the fear of men, conscience from the fear of God" Samuel Johnson

Frederick W. Robertson, the renowned pastor of Holy Trinity Church in Brighton, England, spoke of "Black Monday" the day after Sunday when he agonized over the sermon that he preached. This giant of a preacher had a sensitive nature that caused him to worry about the things he said in his sermons. People came from all quarters of the city to hear him preach each week because he had his finger on the pulse of the ordinary man's daily experience. He was a gifted illustrator with profound insight into the things of the Spirit; he was capable of providing for the common man a trail on which to walk through the valleys of life. However, he suffered from many mental self-inflicted wounds. Rev. Robertson is not unique in his experience; many pastors (including renowned men like Charles Spurgeon) suffer from the same condition of worry and regret on Monday. It is not only seen among the young and inexperienced preacher, but the mature and seasoned ones as well.

Sunday Service

The morning service was splendid as the worship brought the people into the chambers of heaven. Now it is time for the message, the main ingredient of the service and the preacher is poised as a hitter on deck waiting for the moment when he stands before home plate to deliver the game winning hit. All eyes are on him as he meticulously introduces his text and subject for the morning. Prepared with a story to disarm the tension of the audience, he moves systematically through his introduction and then into the body or core of his morning dissertation. With each point that is made in support of the text the congregation gives a response by clapping their hands, some nodding, while others give verbal praise affirming the relevance of the sermon to their lives. The Spirit descends upon the congregation in response to the message and ministers to the open hearts of the people. As the final summation is given, the audience stands in celebration of the impartation received. The preacher, as a fisherman casting his net in the sea, now begins to retrieve his net full of seekers responding to the clarion call. So numerous is the response, that there is an inner sense of glee and satisfaction that he has preached the full council of God. The closing prayer is given and the preacher stands to greet the

members and visitors in the back. After which he collects his things and retires until his next assignment.

Black Monday

For many preachers this type of experience is not the norm but rather a once in awhile experience. While it is not true to form for many preachers, there are those who can identify with it. When this happens, the preacher normally leaves with a sense of fulfillment at the end of the day. For many pastors and preachers of the gospel, the end of the sermon on Sunday sometimes gives way to the feeling of anxiety and stress especially if they sense the sermon was lacking due to hasty or inadequate preparation. There are those who experience the reality of sunny Sunday giving way to Black Monday that Robertson describes. Did I say the right thing? Did I say it in the right way? Did I make sense? What are the people thinking? I wish I did not make that statement. I wish I could take those words back. These are the many thoughts that often plague preachers on Black Mondays. Some go into a state of depression for a few days, while others just shake it off with a promise to do better next time. For the truly sensitive preachers and those that are perfectionists, they find it difficult to shake it off for a season until the next message is given. Preaching in the twenty-first century requires more today because this generation is mentally programmed for "sight and sound" and the preacher is asked to be a court jester or entertainer just to keep the audience's interest during the sermon. To do anything less is to fall short of the expectation of the audience. (This is not true of all churches.) Having this on their minds when they mount the pulpit places a lot of stress on today's preachers to make the sermon exciting and exhilarating. Preachers sometimes dress like a character in the sermon, or use props on the platform to reflect the theme of the message. All because it is believed that this is the most effective way to reach this generation.

Each service requires a great deal of preparation in addition to prayer and sermon development. Today's preacher is expected to deliver an awesome message and, if at the end of the sermon the audience does not respond with a positive affirmation then the preacher leaves feeling unfulfilled.

Preachers are like little children at a recital giving a performance; they like to feel appreciated and stroked. When that is absent, they send out the invitation to their pity party. The apostle Paul's method of dealing with such feelings can been seen in Galatians 2:20, "I have been crucified with Christ; it is no longer I who live, but Christ lives in me . . ." A crucified preacher knows that he is dead to his feeling of self-centeredness, pride, and the need for affirmation after a message. He understands that he is only a mouthpiece, a vessel through which the living water flows to the dry and thirsty land. To allow feelings of inadequacy and insecurity to overwhelm them is to open the door for the enemy to get a foothold in their mind.

To be an effective preacher in the twenty-first century, one must understand the power and influence of both words and the pulpit. He who stands in the pulpit on Sunday is perceived as the voice of God, especially for those who are seeking direction for their troubled souls. Therefore the preacher must be cognizant of the words he preaches because once released, they cannot be taken back. It normally has a greater impact than was intended. There are two things that I would like to stress in this chapter. The preacher should not be overly sensitive or overly confident in his message and in his delivery. To be overly sensitive means that one's soul will be troubled thinking about whether or not he pleased God and satisfied the needs of the people. To be over confident sometimes leads us to make presumptuous remarks that comes back to haunt us at a later date.

It is not wrong to think about the delivery, or to wonder if it made a difference in the life of the people. We have a problem when our mood is deeply affected by the thoughts of failure and guilt. How do we overcome these feelings that plague the mind? Prayer! That means prayer before and after the sermon. I don't say this in a flippant way, but sincerely and honestly. Back in the 70's when I was a student of homiletics, our teacher would say to us, "we need to pray like it all depends on God and prepare like it all depends on us." Then you stand up and declare thus says the Lord, and let the chips fall where they may. The preaching of the gospel is God's work done through vessels of clay and our prayer will be the stabilizing force that transforms the waiting heart. Zachanas Tanee Fomum says in his book, *The Practice of Intercession*, "the only work for the

CHAPTER THIRTEEN

Five Sample Sermon Outlines

Sample Sermon 1

Title: Experiencing God through Conversion

Text: Acts 9:1-9

Introduction: A man purchased a dilapidated house and attempted to restore it back to its full beauty. However, after he moved in, he realized that it still had some major flaws. After the first heavy rainfall, it started to leak. Then the electrical shorted out because of the water coming into the panel box. This was only the beginning of his problems. After months of trying to patch things up, he decided to level the entire house, and construct it from the ground up. This process took a while, but in the end it alleviated all of the problems. This illustration is a picture of the nature of conversion. It is not restoration or assimilation, but rather it is regeneration, which means to begin anew.

Conversion is God leveling the old and reconstructing the new (II Corinthians 5:17).

Body:

Paul's experience was not a typical one that happens to everybody who encounters Christ. As a matter of fact, it was a very unusual experience.

There were three aspects to his experience:

a. **It was unexpected**—The last thing on Paul's mind was having an encounter with the resurrected Christ.
b. **It was dramatic**—The blinding light from heaven caught Paul off guard knocking him off his animal and leaving him blind.
c. **It was supernatural**—Paul's men did not see the blinding light nor did they understand what Jesus said to Paul. The Bible said that they "stood speechless hearing a voice but seeing no one."

I. An unexpected encounter—marked by God's timing.

a. It is not an everyday occurrence—this was the first time anything like this happened to the apostle

b. There is a time associated with the visitation—God had a special time in which he was going to reveal himself to Paul.—Everything God does is marked by TIME!

"But when the fullness of the time had come, God sent forth His son, born of a woman, born under the law, to redeem those who are under the law . . ." Galatians 4:4,5

"To everything there is a season, a time for every purpose under heaven: A time to be born and a time to die . . . a time to weep and a time to laugh . . . a time to mourn and a time to dance . . . a time to keep silence and a time to speak." Ecclesiastes 3:1-7.

c. It resulted in Paul's life being changed! Radically, completely, totally! He made a 180 degree turn in his life. 2 Corinthians 5:17

You cannot encounter God and remain the same person!

II—A dramatic encounter—marked by God's power.

a. Having an encounter with God is only the beginning of a journey that will last a life time.-
b. The result of encountering God is Salvation, eternal life—Jesus said, "this is eternal life: that they may know you, the only true God, and Jesus Christ, whom you have sent." John 17:3

c. Knowing God does not come through a program or a method. It is a relationship with a person. And like all relationships it develops based on a person's willingness to spend time with each other, trust each other, respect each other, and with God it involves obeying Him.

III—A supernatural encounter—marked by God's presence.

a. The new birth is a supernatural operation done by the Holy Spirit. John 3:6-7.-

b. The new birth cannot be comprehended in terms of human explanation. It is an act of God void of human intervention and for which man cannot take credit. Ephesians 2:8-9.

c. The new birth results in inner transformation; it is a personal experience with God and the evidence of the encounter is real to the individual involved. Others may not have recognized God's presence on the Damascus Road, but Paul knew it was real.

Conclusion:

In conclusion, the word conversion literally means, 'a turning about.' When a person is truly converted, there is a distinct change that takes place in their life. They go from being spiritually dead to being spiritually alive; from being an enemy of God to being a friend of God; from being a child of darkness to being a child of light.

Sample Sermon 2

Title: How to Recover from a Disaster

Text: 1 Samuel 30:1-8

Introduction: Disasters can strike anyone at any time. David is an example of one who had many disastrous experiences because of Saul's pursuits. If you encounter life's setbacks and disasters, it can either make you bitter or make you better. The purpose of this message is to show how one can recover when disaster strikes.

Body:

I. **When the unexpected happens**—(1 Samuel 30:1*) "... attacked Ziklag and burned it with fire"*

 a. Disaster strikes suddenly without notice

 b. Disaster destroys that which is precious.

 c. Disaster provides an opportunity for God's grace.

II. **How to get through a personal disaster?**

 a. **Weep**—(1 Samuel 30:4) *"... until they had no more power to **weep**."* Weeping cleanses the soul, and allows us to vent our deepest emotions

 b. **Regroup**—(1 Samuel 30:6) *"... David **strengthened himself** in the Lord his God."* Faced with the tragedy of losing his family, David found his strength in God and began looking for a solution instead of a scapegoat.

 c. **Inquire**—(1 Samuel 30:7, 8) *"So David **inquired** of the Lord..."* in the midst of the disaster it is important to ask God for His perspective. Things seem much different when we see them from His point of view.

d. **Pursue**—(1 Samuel 30: 8) *"**Pursue**, for you shall surely overtake them and without fail recover all"* Our lives have been raided by the Amalekites of circumstance, we have been victimized, violated, abused, assaulted, and stripped of the things that we value, but God has a plan for our recovery.

III. **Become proactive in your recovery process!**

 a. Don't just sit and complain about what has happened

 b. Don't play the blame game day after day, week after week.

 c. Don't isolate yourself in a dark room and cut off all contact with others.

 d. Don't eat yourself into a blimp.

 e. Don't sleep the days away . . . like Rip Van Winkle

 f. **Get up and do something!**—Four lepers in 2 Kings 7:3,4 *"why sit we here until we die?" "If we say, we will enter the city, the famine is in the city, and we will die there. And if we sit here, we will die also . . ."*

Conclusion:

The biggest hindrance to our recovery is our MIND! If we can get our mind lined up with the Word of God, and start believing it, half the battle of recovery would be over. Disasters do not have to destroy us; there is hope for a better tomorrow.

 a. **Believe** what God says about our restoration, salvation, reconciliation.

 • "So I will restore to you the years that the locust hath eaten, the cankerworm, and the caterpillar, and the palmerworm, my great army which I sent among you. And ye shall eat in plenty and be satisfied, and praise the name of the Lord your God . . ."

 • **Genesis 50:20** "but as for you, you meant evil against me; but God meant it for good, in order to bring it about as it is this day, to save many people alive."

b. **Forgive** yourself, forgive the one that invaded your life and stripped you of your valuables.

c. **Discover** new relationships and hobbies and begin to live your life again to the fullest.

d. **Cultivate** a support base that you can turn to when the memory drops in for a brief visit until the healing process is complete.

Sample Sermon 3

Title: Family Plans for Success

Text: Ephesians 5:22-32, 6:1-4

Introduction: The Christian family in today's society is challenged on every hand. The Word of God provides us with great resources that help promote the wellbeing of the home. Regardless of the type of family we have, God has a plan for success.

Body:

Three Types of Family Unit:

- **The traditional family**—father, mother, and children born to both parents

- **The blended family**—father, mother, and children from inside and outside of the parental unit

- **The single parent family**—father or mother and children (where one parent is absent)

I The top challenges to the Christ-centered family:

1. CHALLENGE # I—Popular culture—abolishes the standards of morality.

2. CHALLENGE # 2—Parental disrespect—undermines the symbols of authority

3. CHALLENGE # 3—Poor communication—erodes the quality of relationships

II. God's remedies to counteract the challenges?

1. CHALLENGE # I—**Popular culture**—

REMEDY—Dare to be different Christian family!!!! Be in the world, but not of the world. *I John 2:15-16*

2. CHALLENGE # 2—**Parental disrespect**—

REMEDY—Live respectfully and model the respect for others and obedience to God that you expect from your children. Then hold them to firm standards of respect and obedience. Ephesians 6:1-4.

3. CHALLENGE # 3—**Poor communication**—

REMEDY—Make time for quality interaction and engagement. Schedule it! Stick to it! *Mark 6:31-32*

Conclusion:

Family matters to God. In order to be strong, the family should be mindful of God's truth.

- **a.** Allow the Word of God to GUIDE you
- **b.** Allow the parents' authority to GROUND you
- **c.** Allow the closeness of family to GUARD you

Sample Sermon 4

Title: Discipleship through Relationship

Text: John 8:31

Introduction: The word *disciple* means student, learner, or follower of some doctrine or teacher. Thus, *discipleship* is therefore the process of making a disciple. It is possible to be a follower of Jesus without being a disciple.

- Putting on a soldier's uniform does not make you a soldier until you go through the training.

- Lip synching does not make you a singer.

- Wearing a basketball jersey of a famous player does not mean that you can play basketball like that person.

Body:

Once, someone was talking to a great scholar about a younger man. He said, "So and so tells me that he was one of your students. The teacher answered devastatingly, "He may have attended my lectures, but he was not one of my students."

It is one of the supreme handicaps of the church that there are so many distant followers of Jesus and so few real disciples. In the text, Jesus said to the Jews, "If you hold fast to my teachings and live in accordance with them, you are truly my disciples."

I. Traits of a true disciple

- A true disciple of Jesus will have a healthy respect for the truth of God's Word.

- A true disciple will count the cost of his commitment

- A true disciple will be willing to take up his cross and follow Jesus.

- A true disciple is one that is sympathetic and understanding of the hurts and pains of others.

- A true disciple will be a peacemaker and not a peace breaker

- A true disciple will hunger and thirst after righteousness

- A true disciple will be faithful and not faithless

- A true disciple will be selfless and not selfish

- A true disciple will love Jesus Christ will all his heart, soul, and mind

- A true disciple will make other disciples

I strongly believe that the measurement of our commitment to God is seen in our interaction with each other. People are brought to a better understanding of Christ and Christianity, when they see it modeled by authentic believers. Not sinless believers, but genuine believers. Our relationship with Christ rests upon our relationship with Him and with our brothers and sisters.

Sometimes the process of developing relationships can be costly, emotionally painful, mentally draining, and spiritually tiresome. However, that relationship often yields good fruit once the roots are deep enough to weather the storms of misunderstanding and conflict.

Dr. Charles Stanley say, "Whatever problems in human relationships you may encounter, remember that God is actively at work in you, releasing His love, demonstrating His presence, and molding you into His likeness. The hurt, pain, and irritations caused by others are instruments for the advancement of the gospel as well as for your spiritual enlargement and enrichment."

II. How do you become a true disciple?

1. Becoming a true disciple begins with a genuine response to Jesus' invitation to follow Him.

2. Second, it requires a commitment to serve Christ.

Conclusion

In conclusion, I will return to the theme; *"Discipleship through Relationship."* Someone said that 'soul care' is the church's total task. In order for the church to provide adequate 'soul care' for new believers, the church will have to be a place of community and compassion.

The church must be a place of *community:* A place of stability, rest, openness, friendliness, and support. (We need each other.)

The church must be a place of *compassion*: A place of sharing, caring, giving, and serving. (We need to care for each other without compromise). Acts 2:42-46

Sample Sermon 5

Title: All things work together for good.

Text: Romans 8:28

Introduction: This verse is a comforting declaration! No other scripture could have a greater effect on our emotional and mental state than this verse. Wrapped up in this little verse are words of comfort, assurance, deliverance, freedom, and confidence to face the future.

Body:

1. **"And We Know"**—There are a lot of things that we may not know, but we can stand firmly on what we do know:

 - **I know that I am saved, because God has given me the Holy Spirit as my guarantee, my down payment.**

 "In Him you also trusted, after you heard the word of truth, the gospel of your salvation; in whom also, having believed, you are sealed with the Holy Spirit of promise, who is the guarantee of our inheritance . . ." Ephesians 1:13,14

 - **I know that God loves me in spite of my sinful nature**

 "But God demonstrates His own love toward us, in that while we were still sinners, Christ died for us." Romans 5:8

 - **I know that God promises to answer when I pray in faith.**

 "Therefore I say to you, whatever things you ask when you pray, believe that you receive them and you shall have them." Mark 11:24

> • *I know that I am to walk in love with my brothers and sisters*

"Beloved, if God so loved us, we also ought to love one another."—1 John 4:11

2. *"All Things"*—This includes all the experiences that occur in the life of the Christian, both the pleasant and unpleasant things, Things that cause us tears and things that cause us cheers. Things that made us happy and things that made us sad.

3. *"Work Together"*—Someone said, "These words means, to create and eliminate, place and replace, connect and group, inter-relate and intermingle, shape and forge, press and stretch, move and operate, control and guide, arrange and influence." The words *"work together"* are also present action which means that all things are continually working together for good. God is in control of the believer's life. Daily, moment by moment, God is arranging and rearranging all things for the believer's good.

4. *"For Good"*—The word "good" means for the ultimate good. We cannot see the future; we cannot take a single event and see all the lines and ramifications that run from it. But God does; He takes all the events of our lives and works them out for our ultimate good.

5. *"To them that love God and are called according . . ."* God works all things out for good only for those who love God and are called according to His purpose. In the Greek the clause, "to those who love God" is placed first in the sentence

"But we know that to those who love God all things work together for good." God only looks after the affairs of the person who love Him.

Think about it for moment; If a man does not love God, does not place his trust in Him, ignores the Lord of all, the master of the universe, turn his back on God. How can God look after Him? How can God bless him?

God is not going to force His care or love upon any of us. Because He made us free moral agents, with the ability to choose to respond to his love. He does not want us to be mechanical robots programmed to give the desired response.

 a. *We are free to love Him*

 b. *We are free to worship Him*

 c. *We are free to trust Him*

 d. *We are free to fear Him*

 e. *We are free to follow Him*

 f. *We are free to pray to Him*

"God has so framed us as to make freedom of choice and action the very basis of all moral improvement, and all our faculties, mental and moral, resent and revolt against the idea of coercion." William Matthews

For those that trust and love God, He says,

"Fear thou not; for I am with thee: be not dismayed; for I am thy God: I will strengthen thee; yea, I will help thee; yea, I will uphold thee with the right hand of my righteousness." Is. 41:10

 6. **"His purpose"** God has a purpose and a plan for every believer; according to Jeremiah 29:11, that plan is for good and not for evil, to give us a future and a hope. The awesomeness of God's creativity is seen in His ability to take all of our negativity, ugliness, mistakes, achievements, and shortcomings and mix it together in a recipe of success. If we believe what his Scripture says, we should never walk fearful of our future.

Conclusion

When the believer is in the perfect will of God, he can rest knowing all things will work out for his good according to God's plan. Therefore, it is imperative that the believer embrace this promise wholeheartedly. By

doing so, we can rid ourselves of stress, anxiety, fear, and pressure when we encounter difficulties or setbacks in life. The specific hardship may not be pleasant, but we can rest assured that in the sum total of our life, God will use even those unpleasant experiences to work together for our good because of our love for God. What a comforting thought!